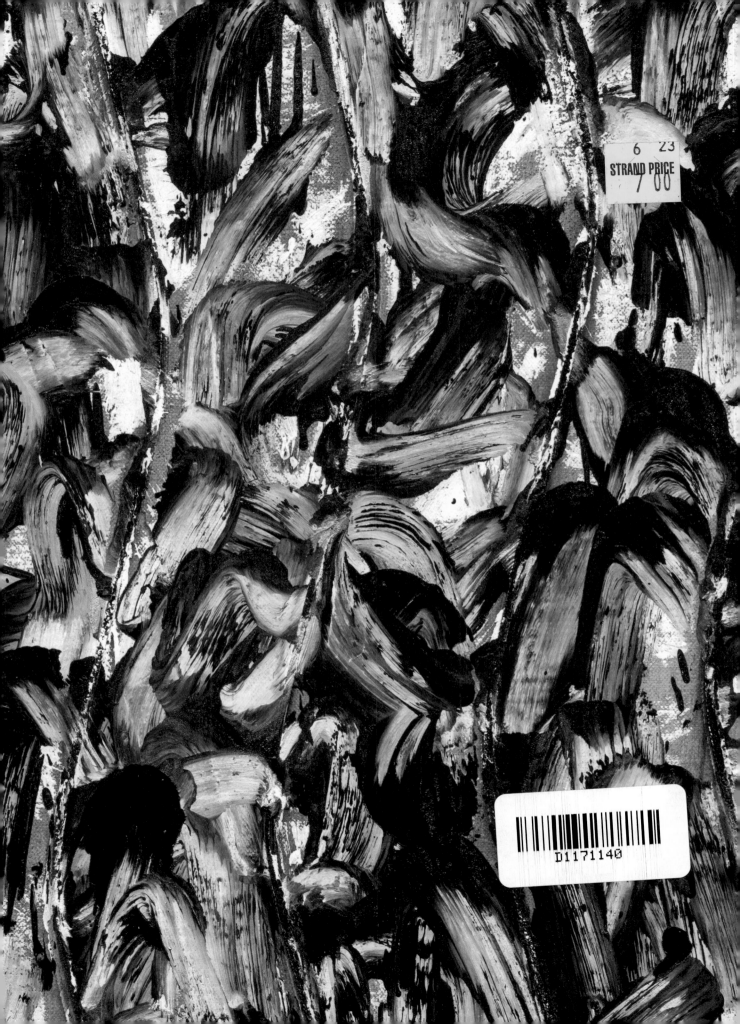

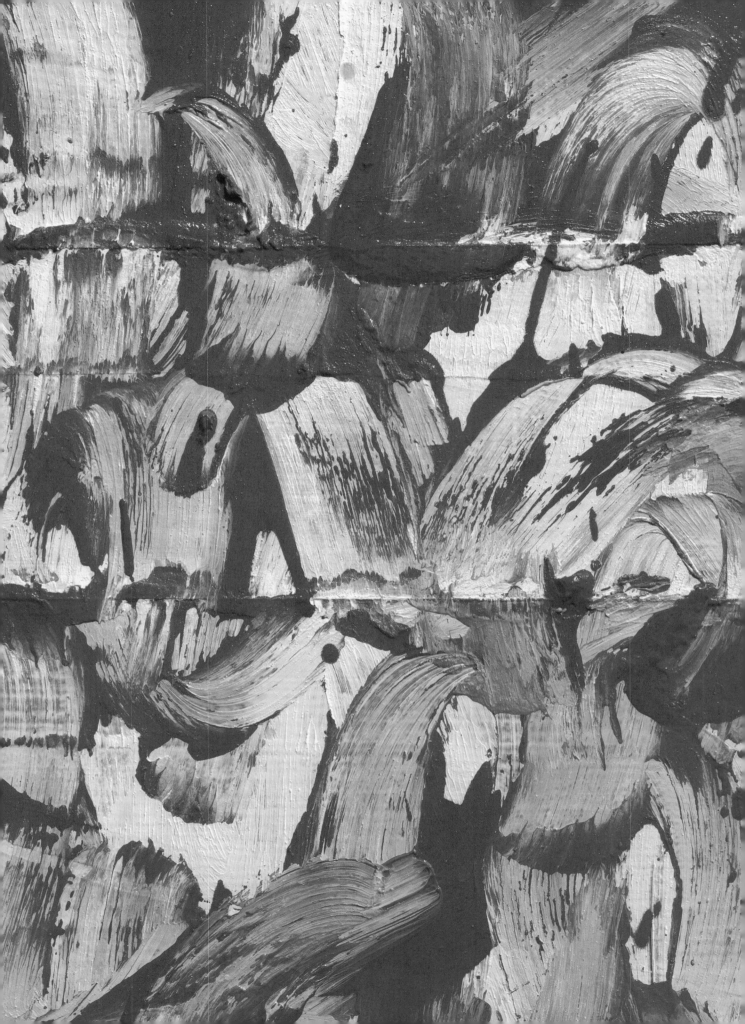

JULIAN LETHBRIDGE

JULIAN LETHBRIDGE

PAULA COOPER GALLERY
NEW YORK

CONTEMPORARY FINE ARTS
BERLIN

SNOECK

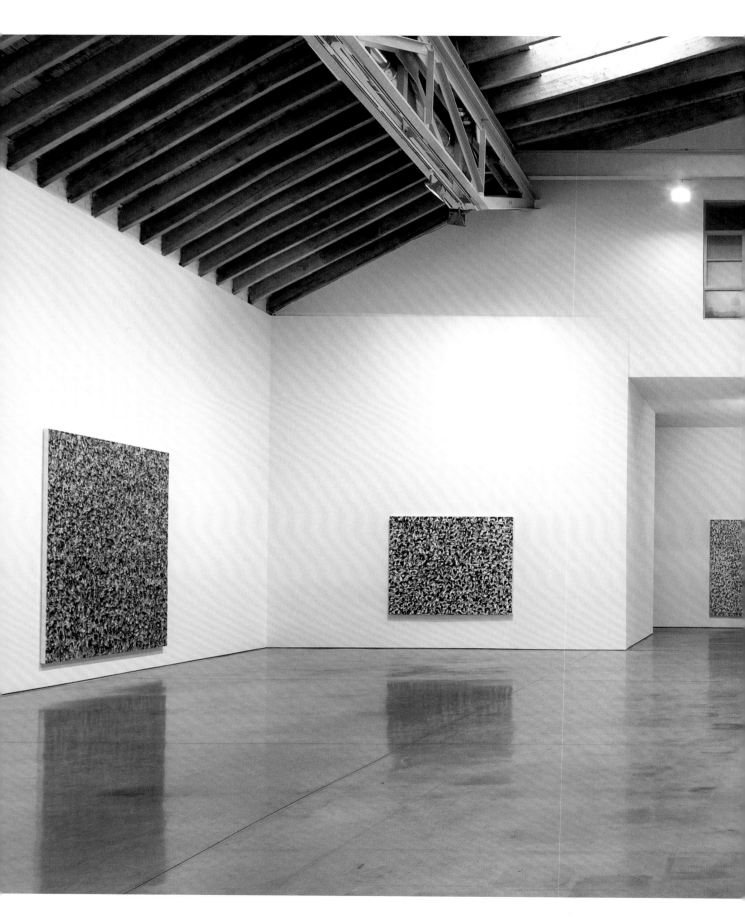

Installation Paula Cooper Gallery, New York 2013

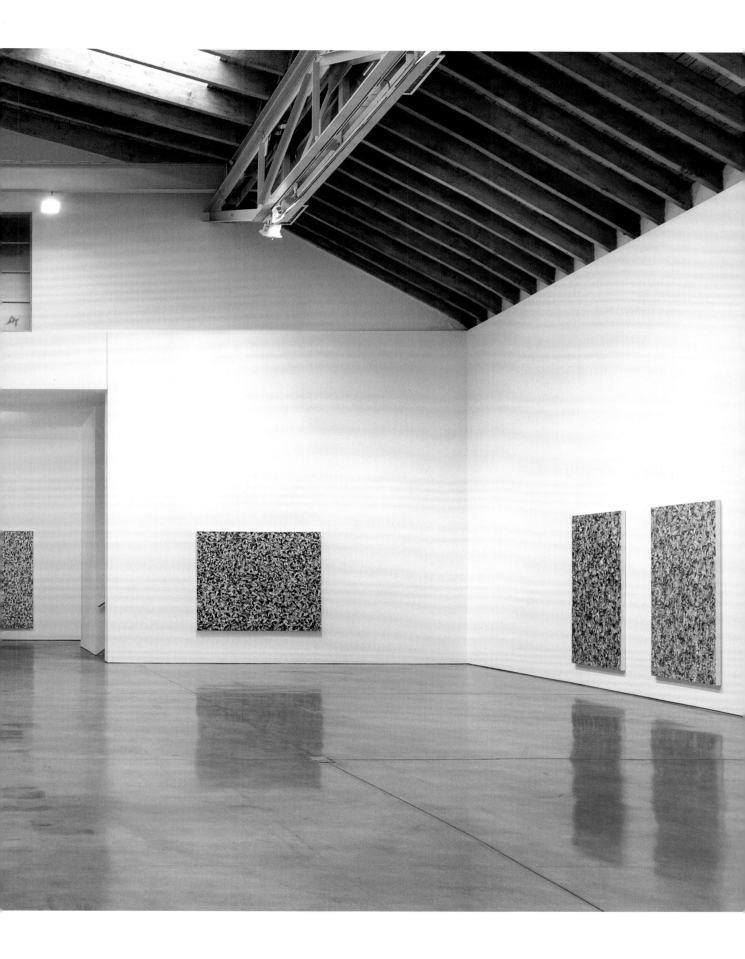

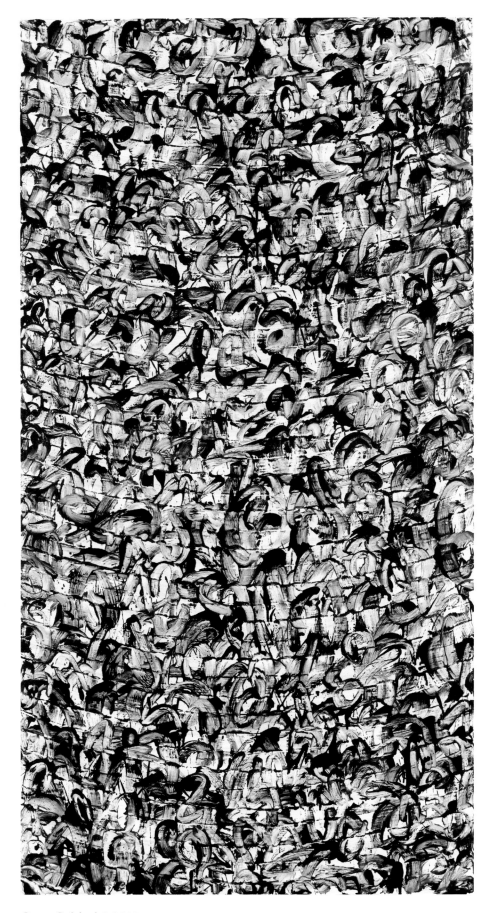

Core Orbital 2 2015

No Stone Unturned

All-over gestural abstraction is a quintessentially American-type of painting. Such a statement might inspire uneasiness or even alarm in a period of our nation's history more chauvinistic than any we have known in decades. Were it not for the fact that the artist about whom I am going to speak was born in Ceylon and grew up in Great Britain. That noted he has been a New Yorker since 1972, making Julian Lethbridge's story a typically American one of successful immigration. Except for the Native American population "we" all came from elsewhere at different times and for different reasons, texturing, variegating and marbling this country's culture in wondrous ways.

In essence "all-over American-type painting" is a rubric that can be applied to a broad sweep of post-1950s art—broader certainly than the scope originally intended by Clement Greenberg who coined the term—ranging from that of Jackson Pollock, Philip Guston and Willem de Kooning to Jasper Johns and Cy Twombly. Its common denominator can be found in the working principle that the amalgam of marks evoking the more or less representational, more or less poetic image—in some cases, such as Johns', they may constitute an utterly prosaic picture—is *in itself* the image.

Likewise, the emphasis the creator of such works places on individual marks is as important to the whole as any pattern they may establish, any gestalt to which those separately improvised images may contribute. Indeed, the subtlest of variations among brushstrokes that may superficially appear to resemble one another, or among gestures and shapes that may initially seem programmatic, are there to point to the lesson that those variations are the crux of the enterprise. In keeping with such a pre-occupation with the differences contained in apparently similar elements each mark, gesture or shape constitutes a unique painting within a larger composite painting, and each painting—to the extent that they evolve in series and are shown in clusters or groups—is by the same token there to make us look harder, savor more fully, and take greater pleasure in being puzzled by nuances it would otherwise be easy to ignore or take for granted.

Those nuances are warnings against the pitfalls of inattention. Quietly posting them across the painterly field of his canvases is the meticulous, palpably intuitive and intensely sensual task Julian Lethbridge has set for himself. When I first encountered his work the examples I saw in the collections of people who favored the bold-faced names of the 1960s through the 1970s were mostly small. In context, Lethbridge's exquisite canvases covered with finely grained grisailles lozenges were the grace notes to other louder, more physically aggressive

compositions. As such his work struck me as that of a *petit maître* in contrast to the more declarative ambitions of theirs and I was grateful for his discretion relative to the overreach of some with whom he shared the walls.

No longer. Composed of gestural units that were always inherently restless but have now been fully unbridled, Lethbridge's canvases have grown exponentially into expansive, scintillating fabrics of brushstrokes that are constantly aligning and realigning themselves into nested curves and counter curves, rhythms and counter rhythms, currents and counter currents of rich oleaginous pigments that won't let the eye go once it has been captured by their elegant, never repetitive but ever-changing fluctuations. In them a paint knife smear assumes the refinement of the classical arabesque, and, synesthetically, you can almost hear the succulent tones as they slide and skip across the surface.

Full strength color has also entered the picture—literally— with the dominant blacks and grays plus opalescent pinks yielding to full strength reds and oranges.

The visual and tactile density of the largest of these paintings is like nothing previously seen in Lethbridge's art, signaling, perhaps, a turning point in a body of work that has heretofore undergone steady, incremental metamorphosis. For the present, though, I am content to value Lethbridge's recent paintings for what they are rather than for what they portend. The expression of an instinctively reserved, thoughtful, disciplined but unapologetically hedonistic sensibility, his canvases dazzle and entice with a refinement that is at once exigent and readily accessible to all with the requisite combination of patience and appetite. Taking the larger, longer view, they are perpetual motion machines whose whirring dynamism shows us that all-over American-type painting remains an open parenthesis in the history of modern art— work that needs to be done.

Robert Storr
Brooklyn, 2017

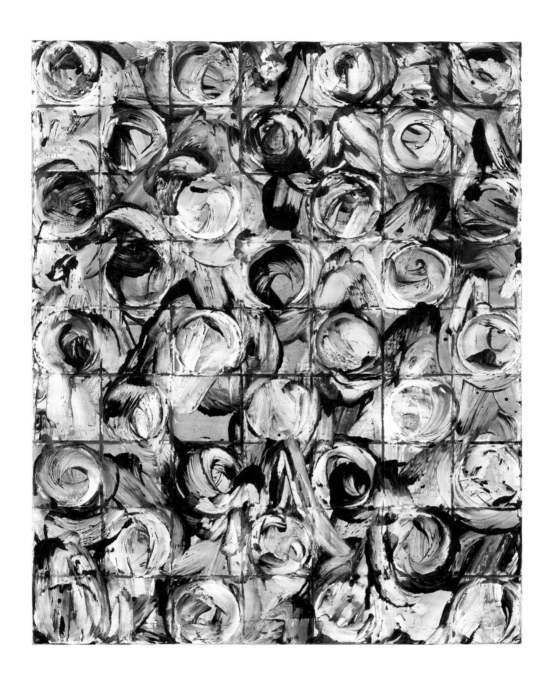

Untitled 2015

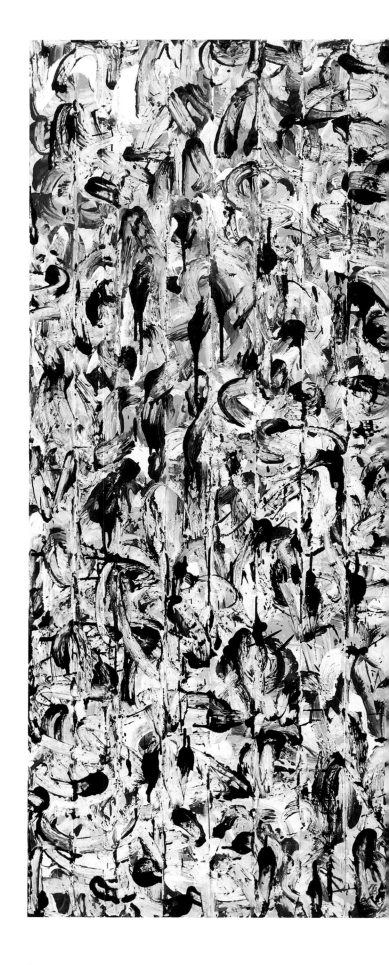

Lost and Found 2013/2016

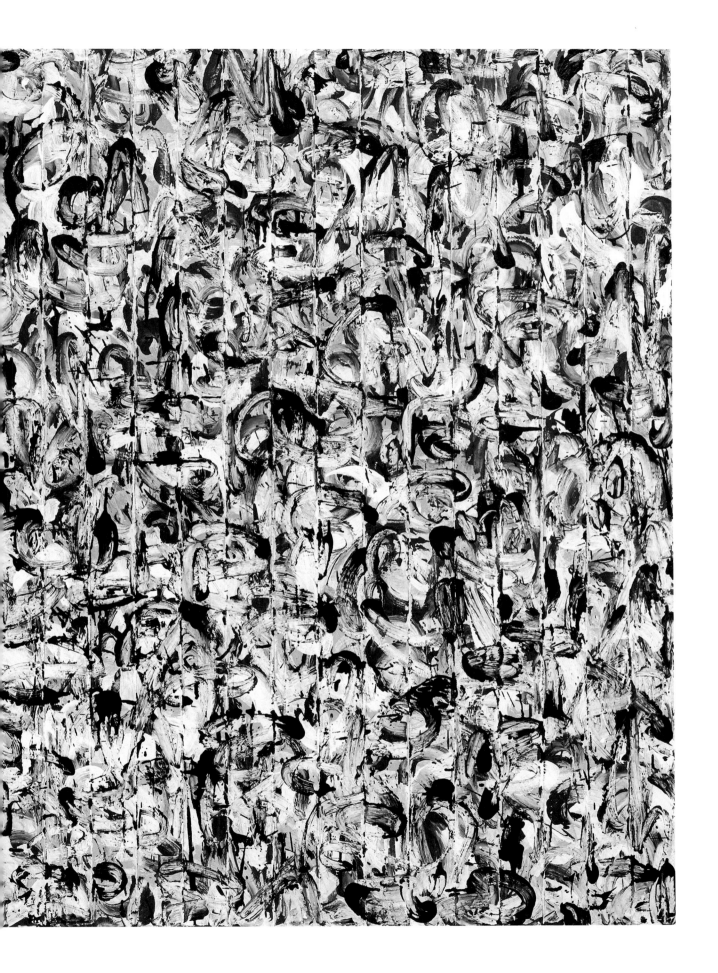

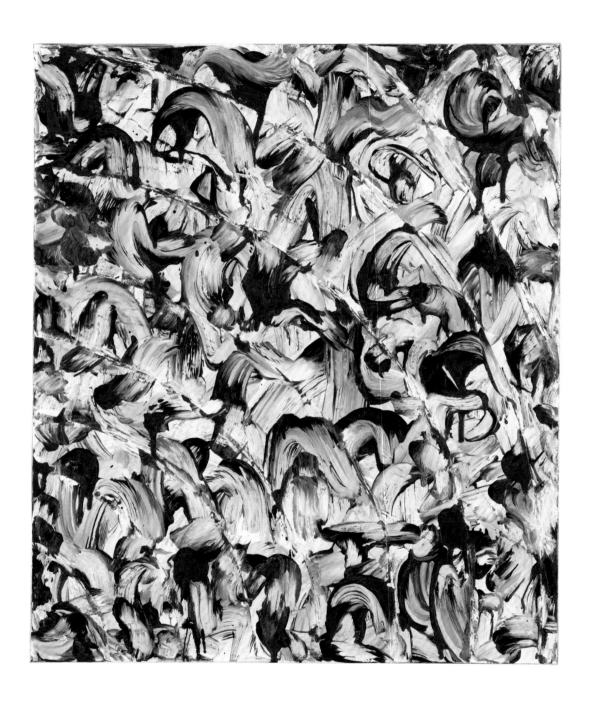

Study for Screen Tool 1 2016

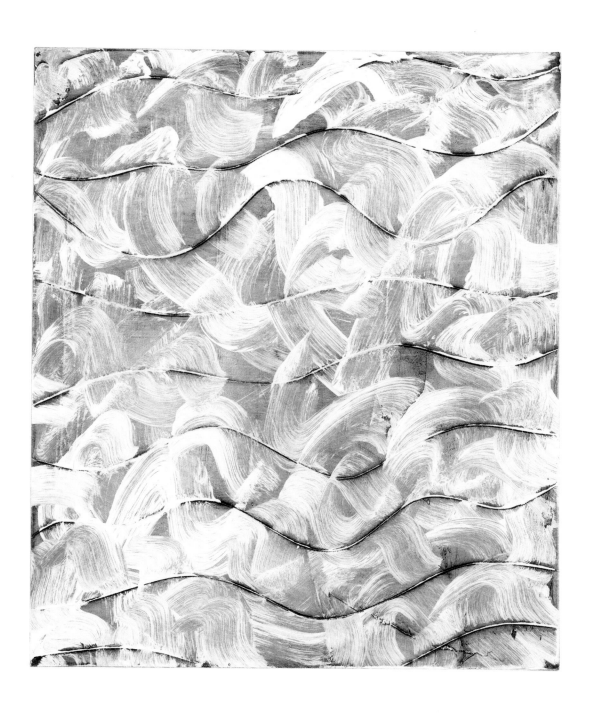

Study for Screen Tool 2 2016

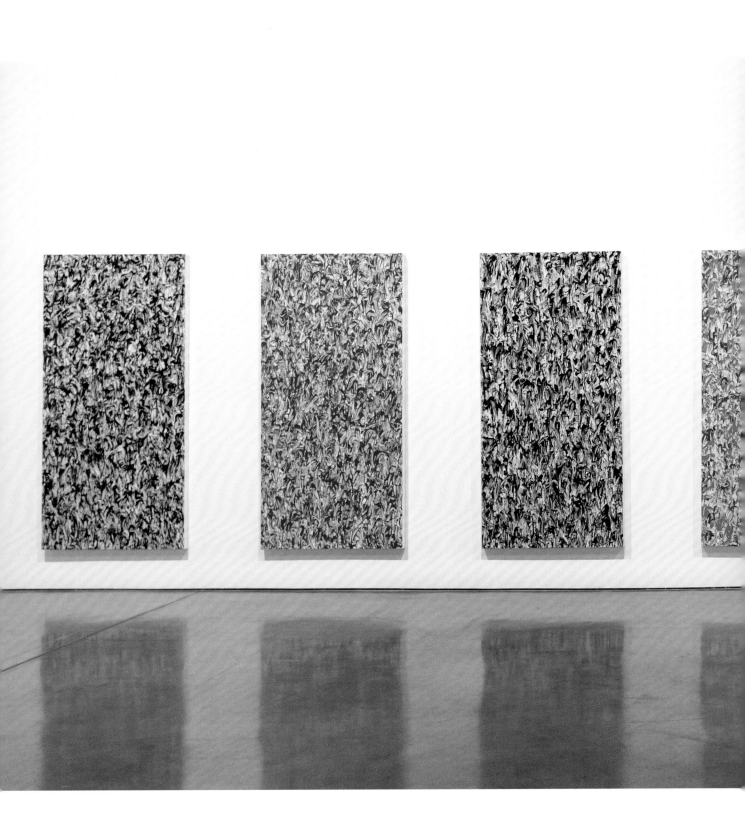

Installation Paula Cooper Gallery, New York 2013

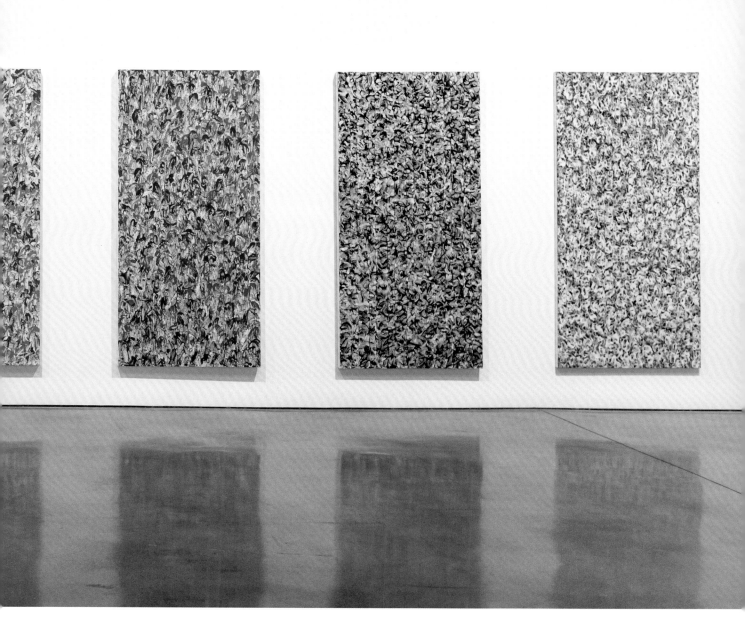

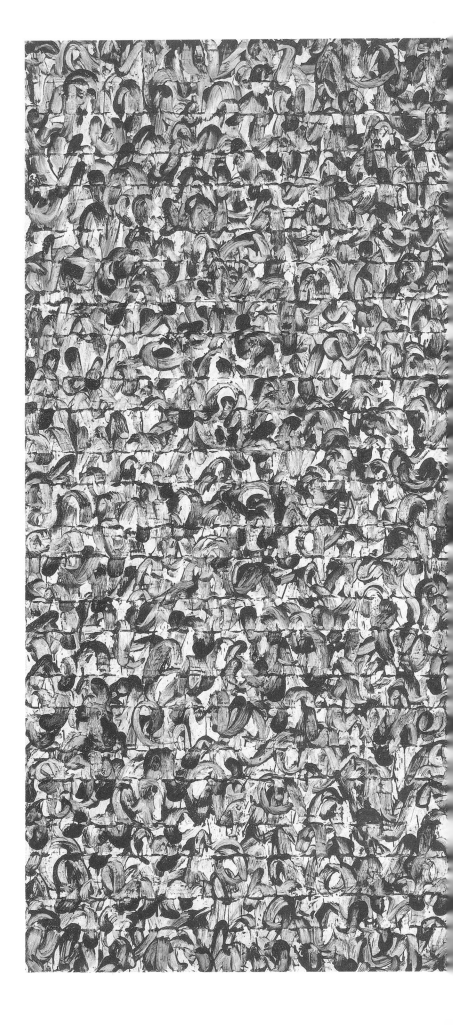

Untitled 2012

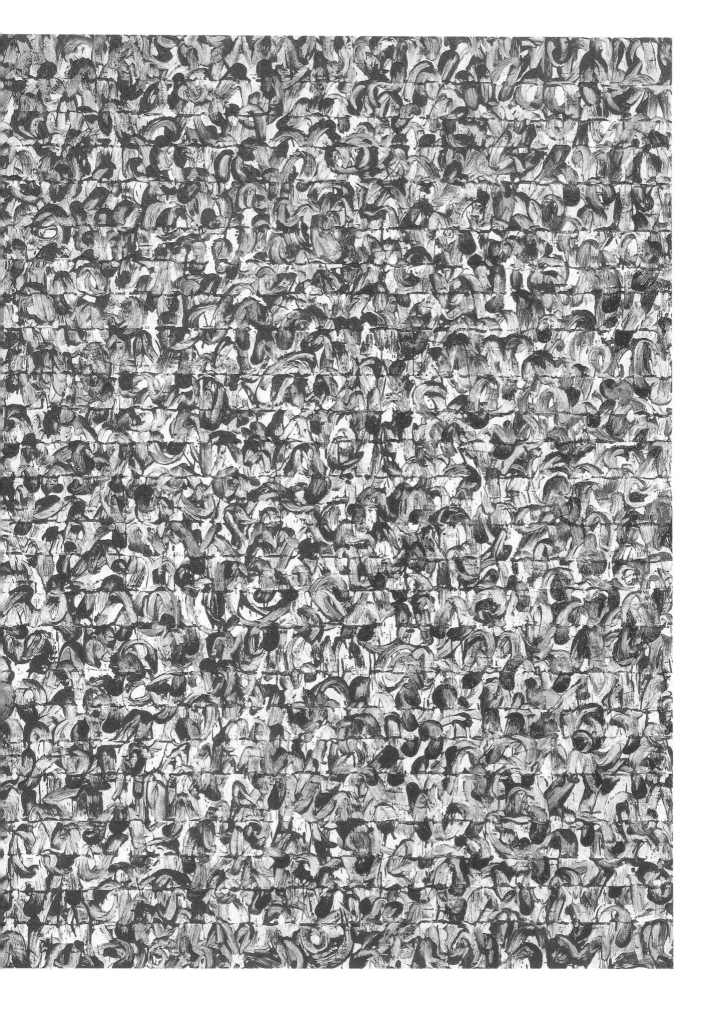

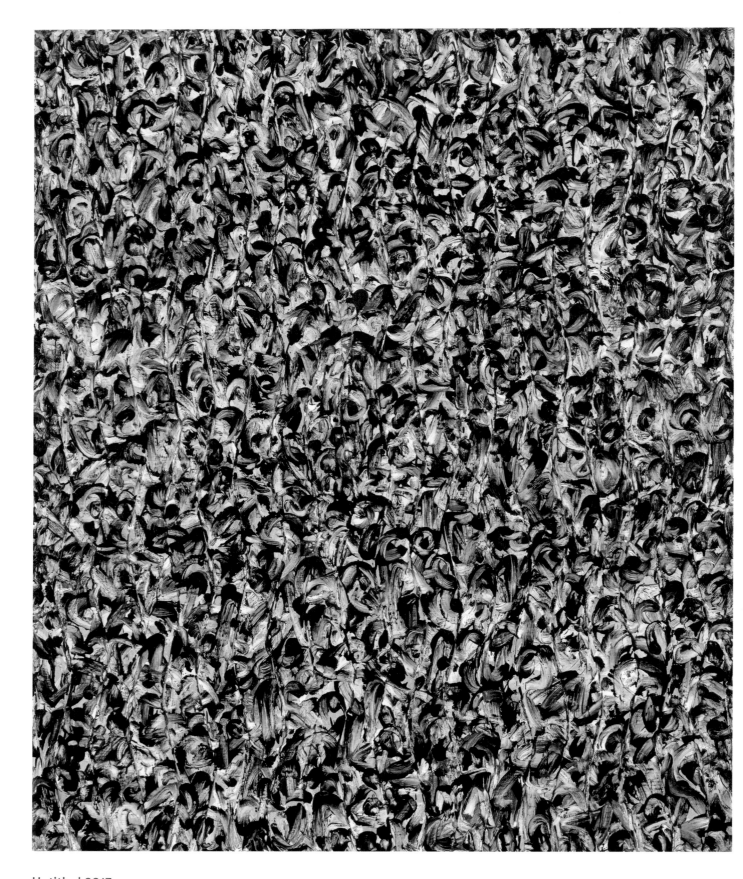

Untitled 2013

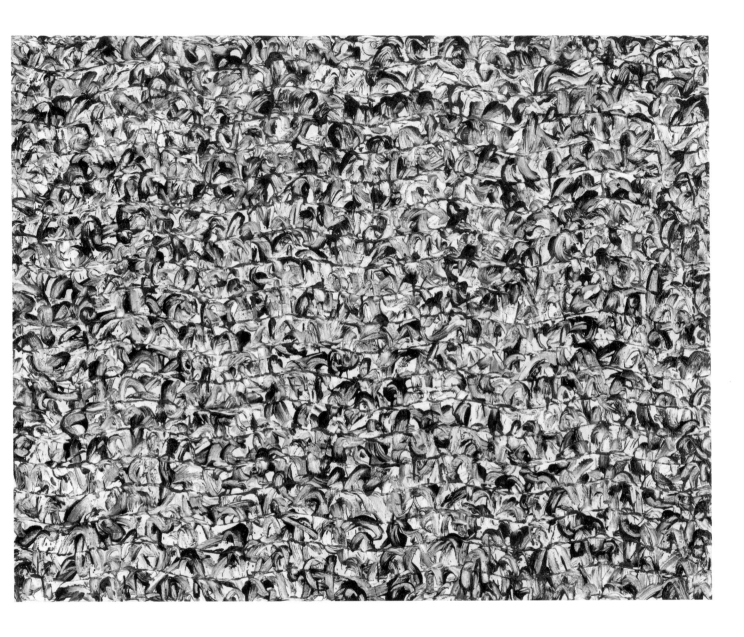

Untitled 2013

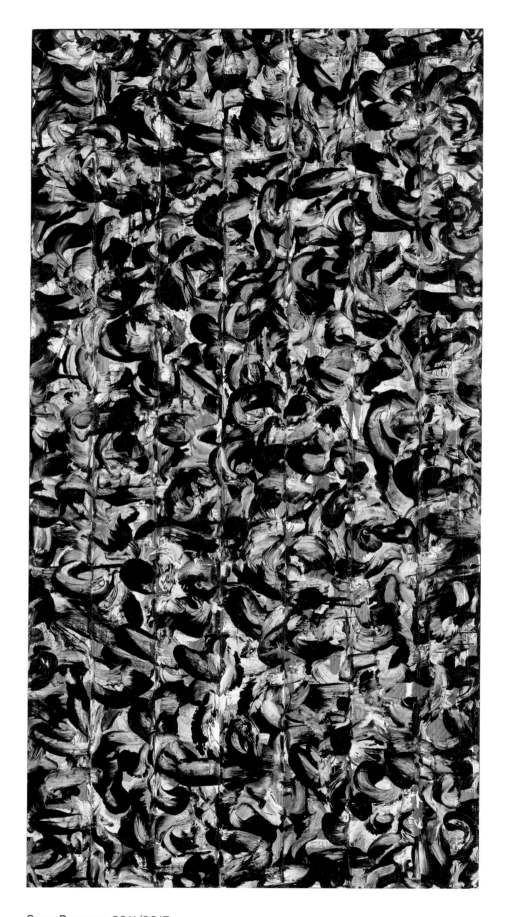

Suez Passage 2011/2013

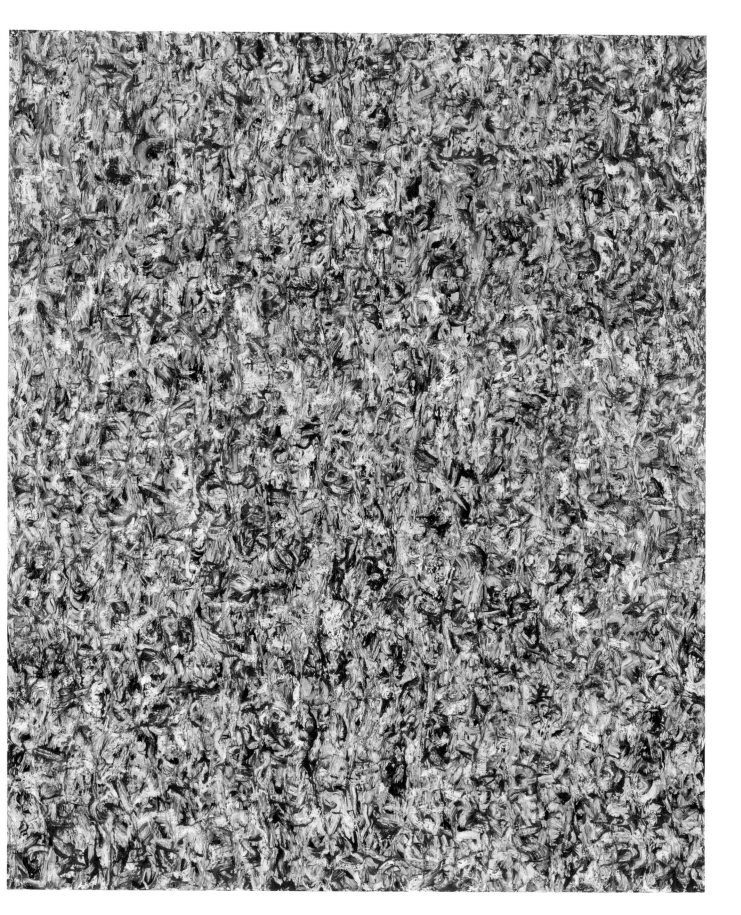

Water Mead 2013

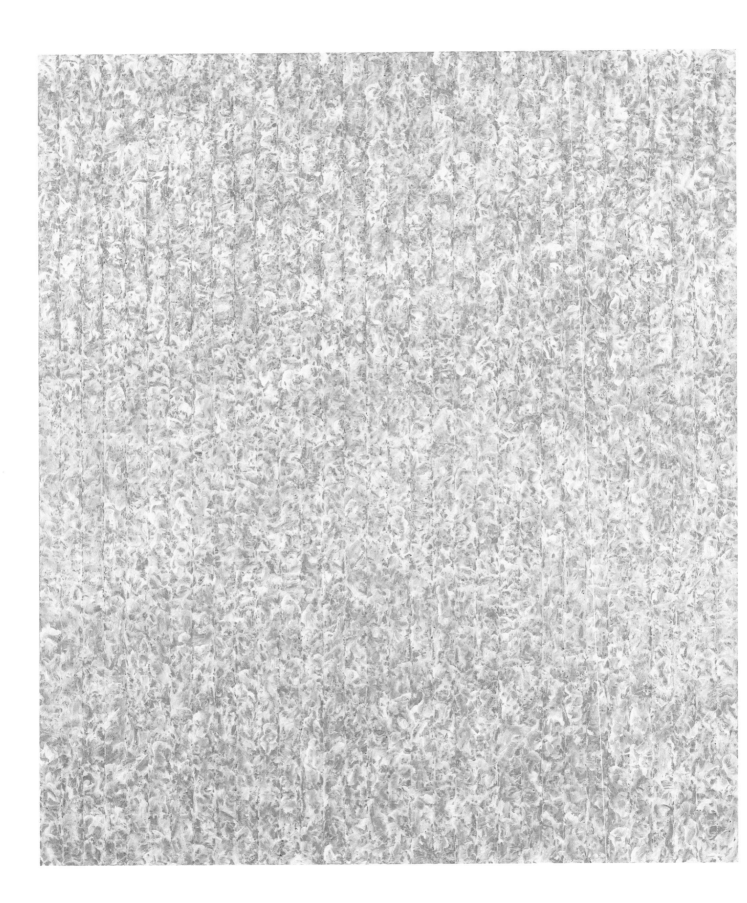

At Sea 2012/2013

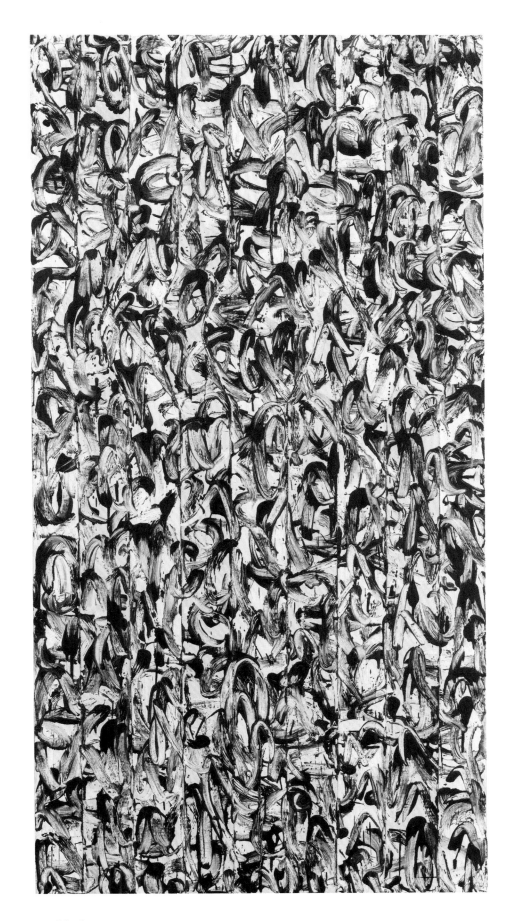

Untitled 2014

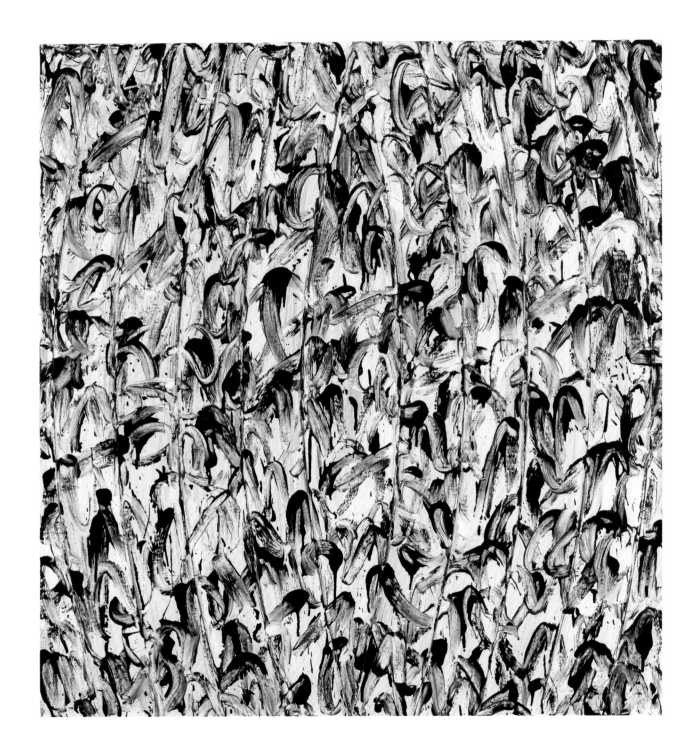

Bellows 2015

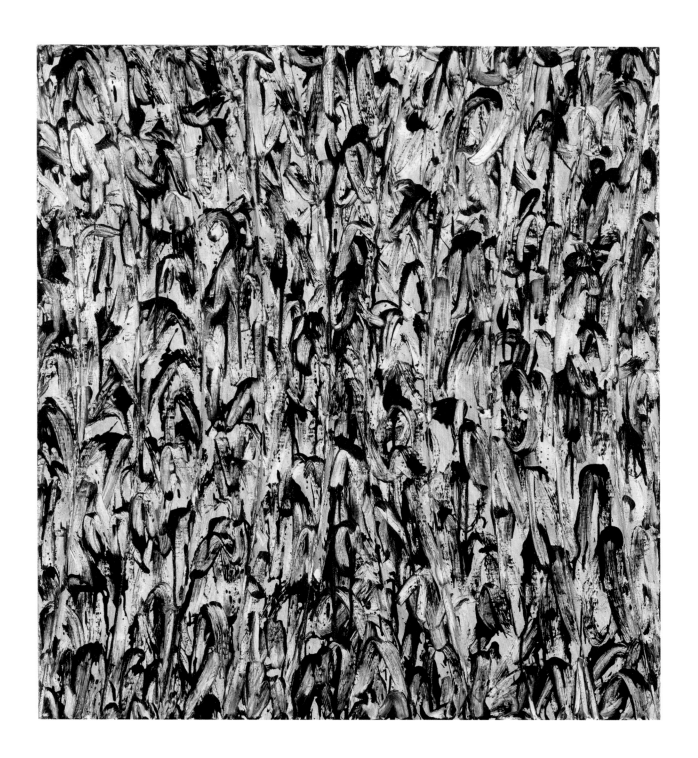

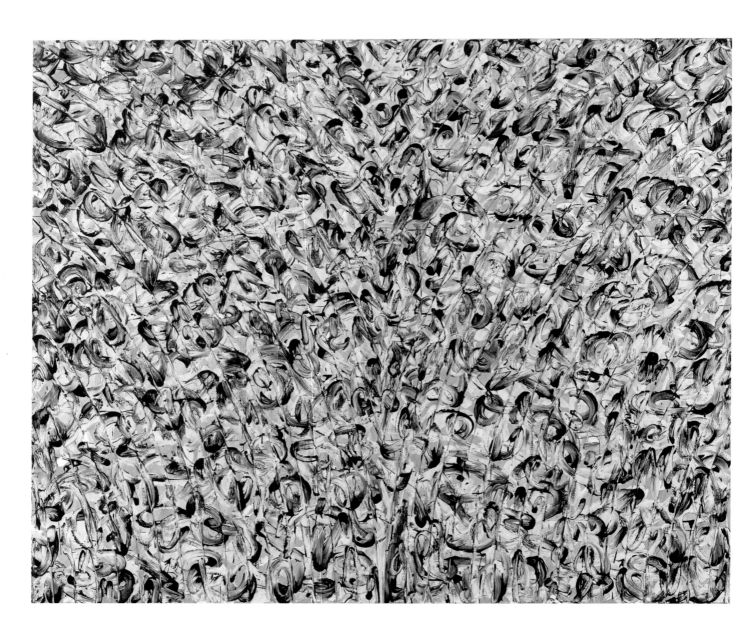

Argos 2016

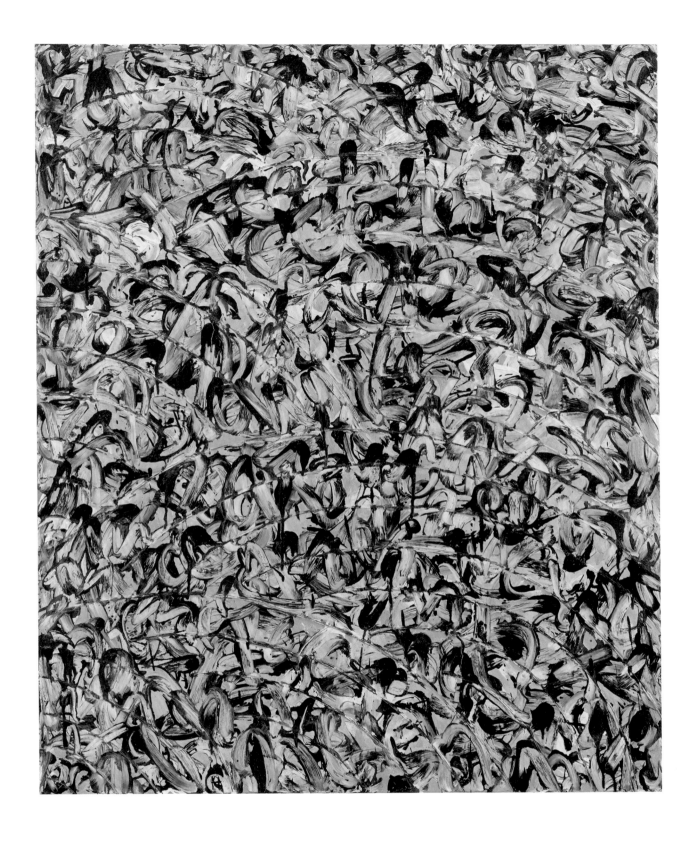

Stucco 2016

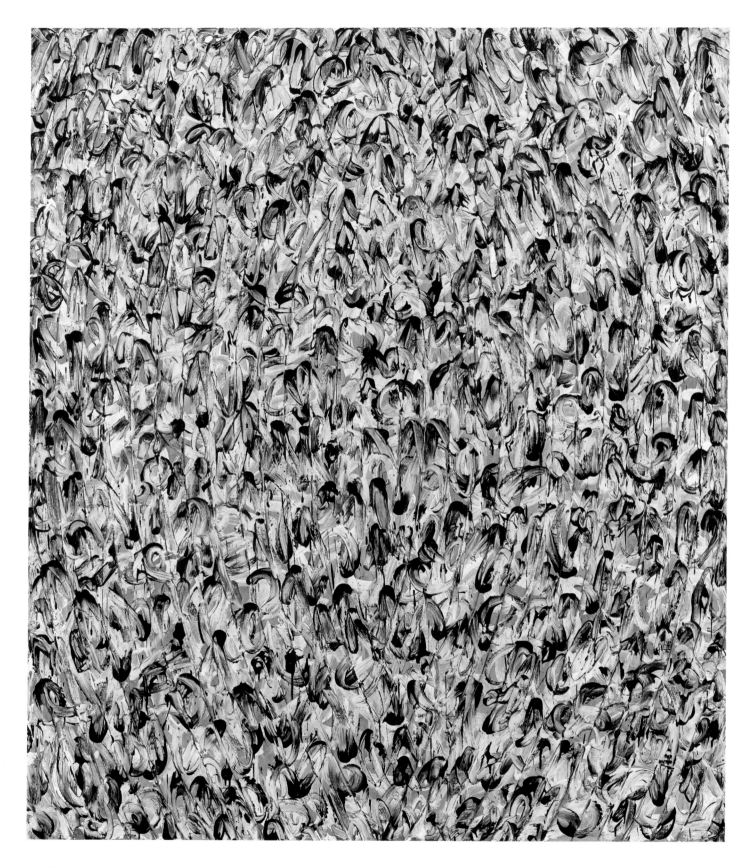

Whitehall Dinghy 2016

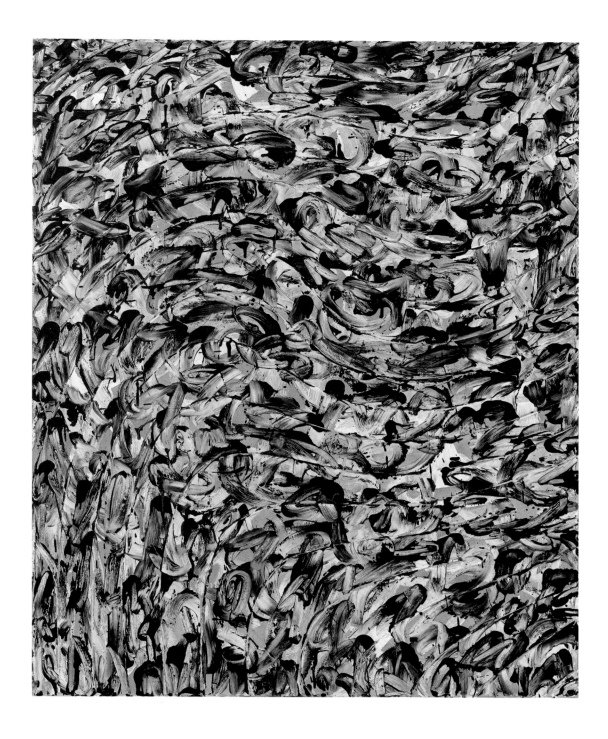

Boreas 2017

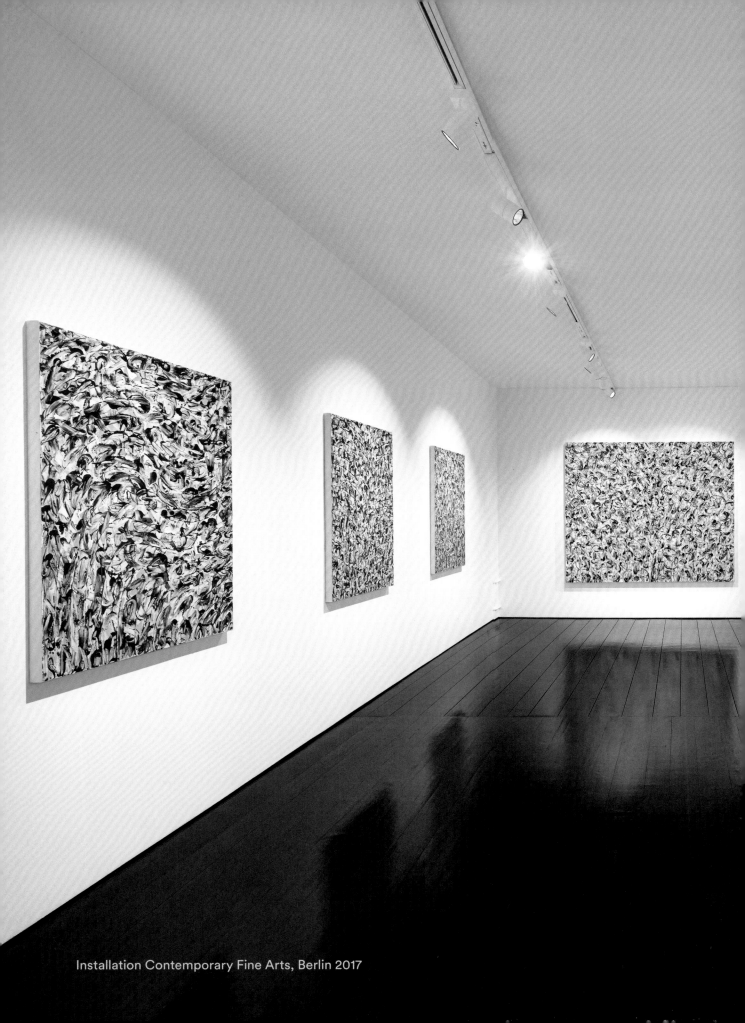

Installation Contemporary Fine Arts, Berlin 2017

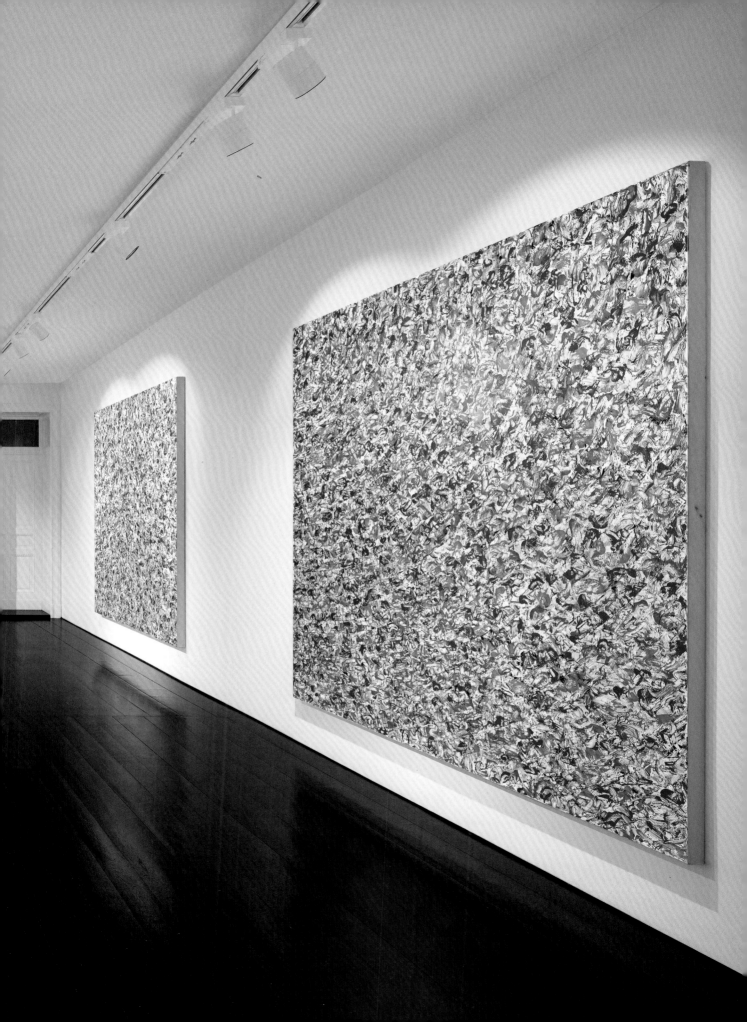

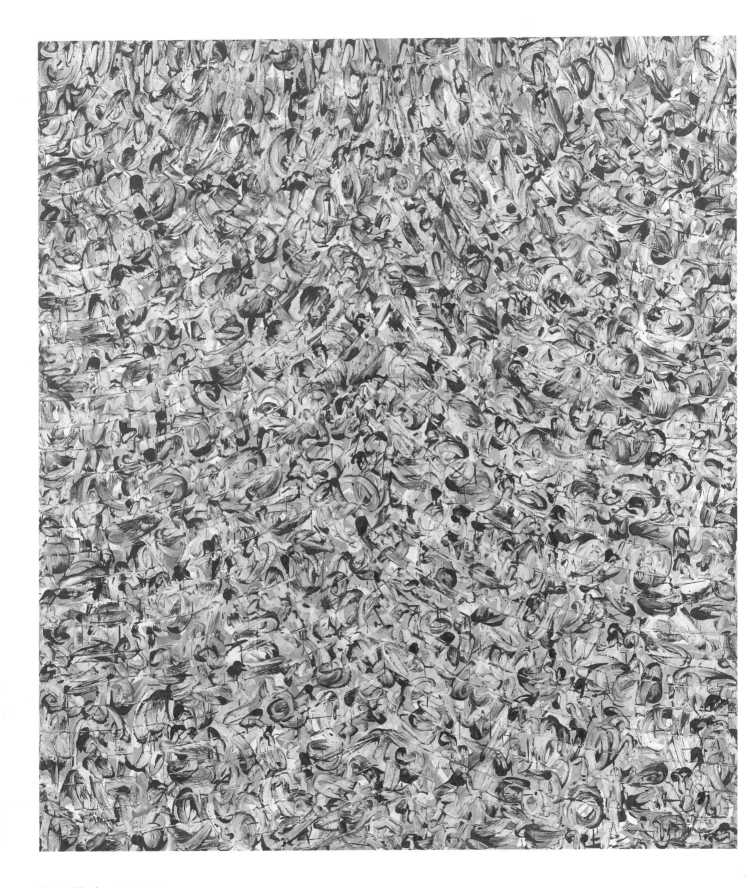

First Choice 2016–17

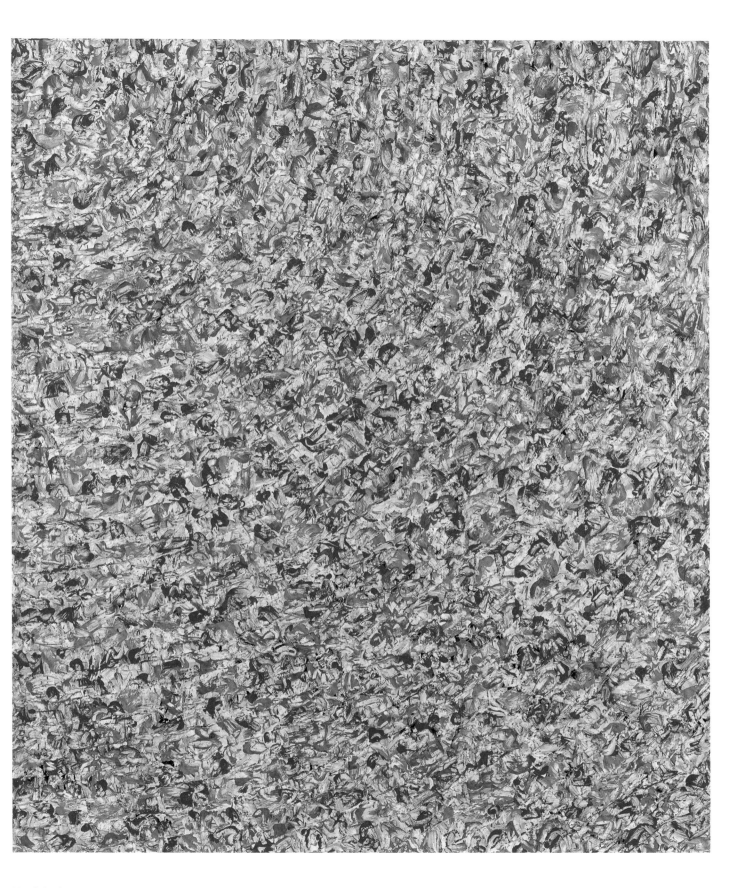

Untitled 2016–17

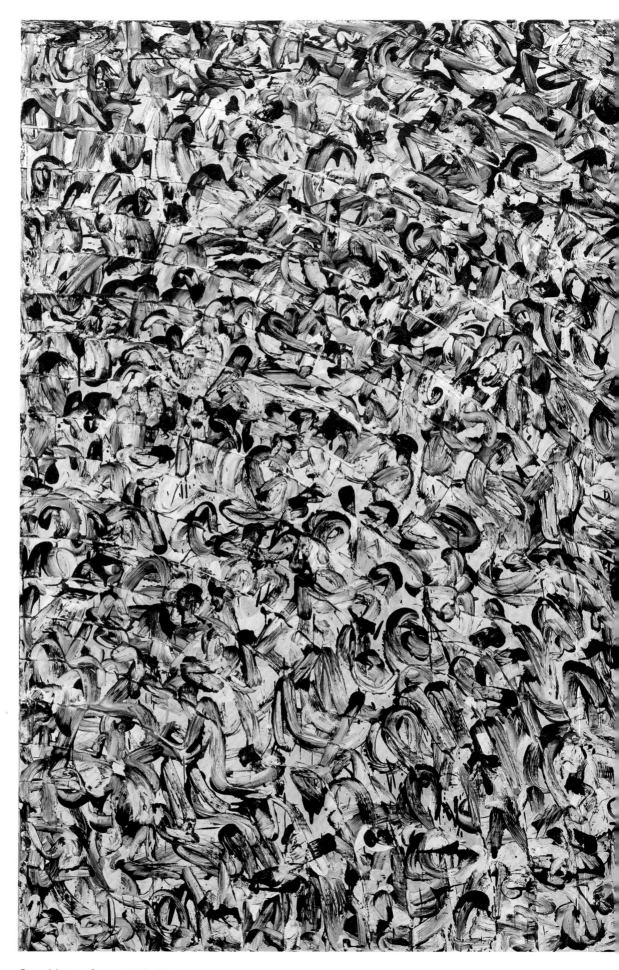

Good Intentions 2016–17

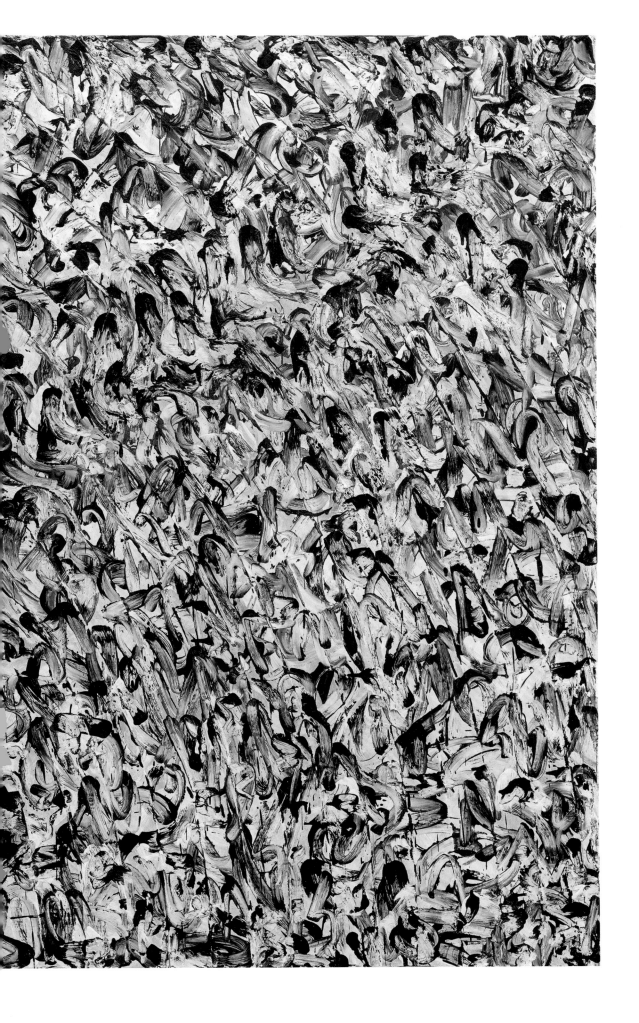

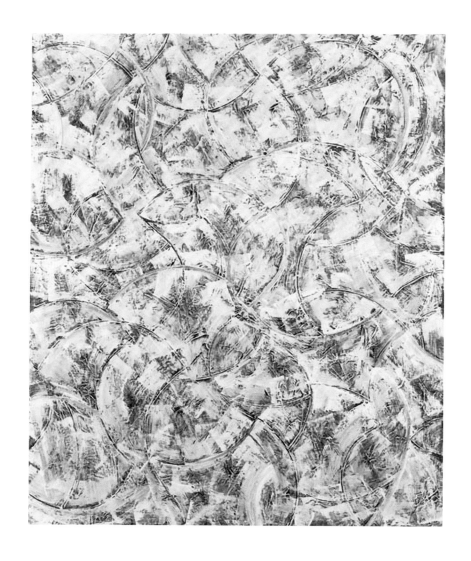

Untitled (Feininger) 1998

Conversation with Julian Lethbridge

Camila McHugh

For Julian Lethbridge, looking is a powerful and pleasurable experience. He is attentive to the way the eye accumulates traces of past experience. His painting probes this constant evolution of visual experience. Describing the experience of the eye, Julian offers a window into a deeply considered way of looking. Working in New York for decades, his oeuvre nods to close friendships with the New York set. Julian discusses how his practice has evolved over time, as New York's downtown community and the constraint of the canvas drive subtle and continuous exploration. This conversation took place over breakfast at The Wolseley in London and through a series of follow-up phone calls in October 2017.

You grew up outside of London, but moved to New York in the 1970s. Do you make it back often?

Not particularly often, but I still feel at home in London. I don't like to travel too much because I like having the option to work whenever I want. I do like the feeling of having travelled though, upon returning home. It is my first "Frieze Week" in London.[1] I have been friends with Amanda Sharp[2] for a long time, long before she started Frieze, so it has been fun to be here and see what they have accomplished.

And you recently did a show in Berlin as well.

Yes, the show in Berlin was really rewarding. I had not shown in Europe for quite a long time, so when Bruno proposed the show in Berlin, I was pleased. Clarissa Dalrymple[3] introduced me to Bruno at a dinner follow the opening of Cecily Brown's exhibition at The Drawing Center.[4] He arranged a studio visit the next day and promptly suggested we do a show. I was concerned because I had a show with Paula Cooper that was imminent, but both Bruno and Paula knew what was in the studio, and seemed eager to go ahead with both exhibitions. I have an unfortunate instinct to postpone things when it comes to showing my work, but in this case the urgency to finish certain paintings was productive. That kind of pressure can concentrate the mind. There are painters I admire who work well with deadlines and others who wouldn't dream of planning shows where all the work to be shown is not complete. I don't think there is a right way and a wrong way. I don't think you can make rules.

Are there any rules or parameters you do adhere to?

I've worked with structures in my paintings for a long time, or perhaps I should say methodologies. I used to think that it would be a mistake to start one painting before finishing a previous one. I thought one should finish a painting and then take what one learned from that one into the next one. Now I

[1] Frieze Art Fair took place from October 5–8, 2017 in London. Other shows on at that time included Rachel Whiteread at the Tate Britain, *Soul of a Nation: Art in the Age of Black Power* at the Tate Modern, *Basquiat: Boom for Real* at the Barbican, *Jasper Johns: Something Resembling Truth* and Brice Marden at Gagosian Gallery, Gary Hume's *Mum* at Sprüth Magers, TJ Wilcox's *Gentlemen* at Sadie Coles, *Wade Guyton: Das New Yorker Atelier, Abridged* at Serpentine Gallery and Kelley Walker at Thomas Dane Gallery.
[2] Amanda Sharp co-founded frieze magazine in 1991 and Frieze Art Fair in 2003 with Matthew Slotover.
[3] Clarissa Dalrymple, b.1940, England, is an independent art curator who organized the first exhibition of the Young British Artists in New York City.
[4] Cecily Brown, b.1969, London, is an abstract painter. Her show, *Rehearsal*, was exhibited at The Drawing Center in New York, October – December, 2016.

work across multiple paintings, and I think one can apply the same learning process working across several things at once. That shift in my "rules" came about in part because of the nature of the way I have been working for a number of years now.

What is that process like?

I usually start by putting a layer of paint on the canvas with a palate knife and then scoring the surface with one implement or another in order to put some structure into the surface of the painting. I do something that creates a disturbance in the surface and then I need that to dry and harden before proceeding. Once that structure is in the painting, I can work within it so that a particular line or mark is present without depending upon a brush stroke to make it so. It separates the structure from the gesture of mark making, or the energy that makes the image one ends up looking at. I've been working this way for quite some time. Ultimately, I think any painter's motive must be some mix of pleasure and an attempt to get to something that doesn't quite have form until you get there. I find that I arrive at a moment where I recognize some kind of resolution of the forces that got me to where I am. It's almost indescribable—it's confined to the moment of the maker and the work at that stage. Hopefully someone else looking at the work later on can recognize that feeling.

Is it that sense of resolution that tells you that a work is finished?

Yes, something like that. Sometimes I leave a painting, thinking it is unfinished, but upon returning to it, perhaps after working on something else, I see it in a new way and it is resolved. I spoke on a panel last year where the question was "When is a painting overcooked?"[5] That is to say, I presume, taken too far. While the metaphor suggests that there was a moment when the painting was "just right," in my experience if a painting is "overcooked" or has become clogged and overworked, it was probably never quite right. Knowing when a painting is finished also raises the possibility of not having gone far enough. Then again, there can be something liberating about a painting that seems to be 'lost,' where the possibility of completing it in a satisfactory way no longer seems to exist. Basically one is then left with three choices. One can destroy it, put it to one side, or continue to work on it with a more reckless abandon. Once whatever original ambition or hopes for the work are abandoned, one can work with a recklessness that may lead to unexpected but gratifying consequences.

Nature had a more palpable presence in your earlier work. Do you feel that you've shifted away from observing the natural world towards engaging an internal logic instead?

I am not sure that this is a shift. I often have an idea for a painting, that may come from an idea in nature, but by the time I finish with it, the relationship to nature can become pretty obscure. The decisions one makes while working are often so immediate, that one cannot be consciously in touch with all the

[5] Art critic Dodie Kazanjian moderated a conversation between Julian Lethbridge and Dana Schutz on the question, "When is a painting overcooked?" in Kent, Connecticut in November 2016.

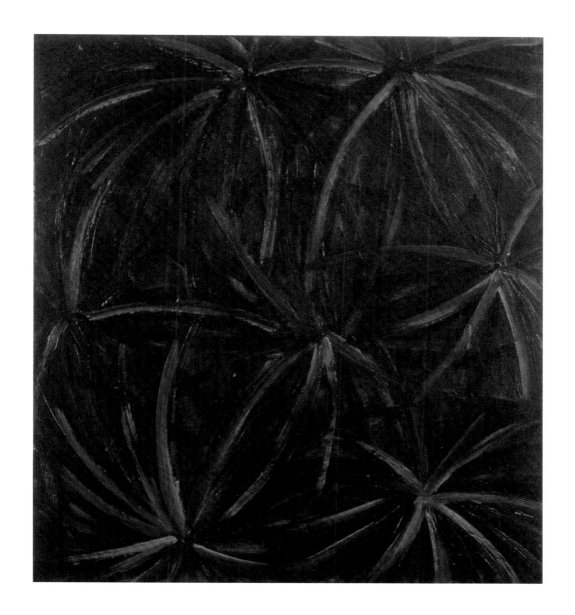

Untitled 1999

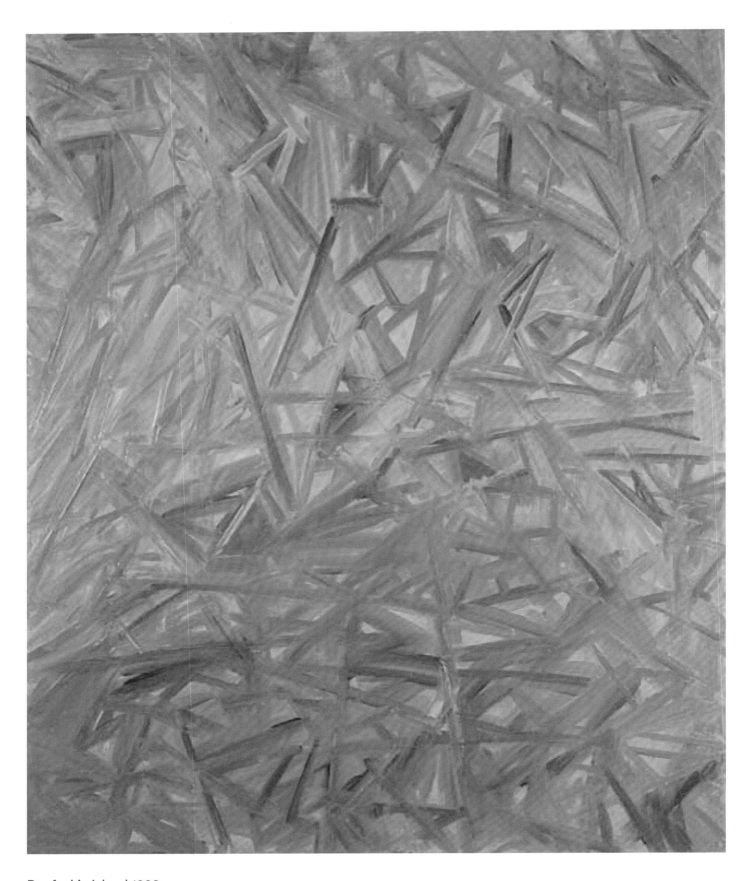

Daufsukie Island 1999

impetuses that go into every decision. The strongest lesson for me in that regard happened after I had been to Cambodia for the first time. I was there about ten years ago to see the temples with a friend. About six months later, someone was in my studio and commented on a smallish painting I had propped up against a wall: "Oh, you've been looking at nature, I see." I replied, kind of indignantly, "What do you mean?" "Well it's obviously the jungle," she replied. And I remember saying, perhaps a little condescendingly, "I beg your pardon, I made that painting long before I went to Cambodia." A few weeks later, I realized I had made a mistake and I had in fact worked on it after coming back from Cambodia. That reflection wasn't conscious at the time. It's a sort of intuitive re-processing of experience.

> What is it like to hear the range of meaning people find in your work?

People bring themselves to the work. If you want a painting to mean something beyond yourself, you need to allow for people to find something in it. I think it's an interesting dynamic. Sometimes a comment seems to me totally absurd, but it is often times more helpful to let that exist than to deny it and push it away. Somebody can see something in a painting that lets you see your own work differently. Perhaps that is why scholars and critics who are trained to see into art in particular ways can be so important to artists. Though Barnett Newman's[6] dictum, "Aesthetics is to artists as ornithology is to birds," also comes to mind. At the end of the day, if you can use something that somebody says, great, and if not, you can simply discard it.

> It's interesting that the way you see your own work can also change.

Definitely. Even without any input from viewers, the way I see my own work necessarily changes. If I want to change a painting, for instance, I can make a mark, add something or take something out. But I can also put the work to one side and work on other things. Then, returning to the earlier work, there is the possibility that it will look different. Sometimes it is almost as though it were a different painting. One does not look at it in the same way that one had before. The eye brings to it whatever may have been learned from the subsequent works. Or something new may be emphasized that was not so evident before. It's a similar idea to wondering what Cezanne's paintings would look like to us if Picasso and Braque had never existed.

> Do you find that looking at other artists' work also impacts your practice?

Definitely. I do not think one can ever really know precisely all the things that impact one's work at a given time. All those things are fluid. At the moment, for example, having just seen Brice Marden's[7] current exhibition of ten new paintings at Gagosian, I have his *terre verte* greens on my mind. I make an effort to see friends' shows—I am primarily in London for that reason. Artists who do not engage with their peers' work are something of a mystery to me. It seems odd to me to work with particular tools and means, and not be interested in what

[6] Barnett Newman, b.1905, d.1970, New York, prominent abstract expressionist and color field painter.
[7] Brice Marden, b.1938, New York, American minimalist artist.

other people who are engaged in similar activities create. After you work for a long time, you create the world in which your thought and work exists. That is partially the context that your previous work has created, but it is also among the community of artists, especially somewhere like New York.

What initially brought you to New York?

It was really a feeling. I had been to the States for a year before starting university and I just had a strong feeling that I wanted to return. At the end of that year, I nearly stayed rather than returning to begin my studies at Cambridge. At the end of my studies, I knew I wanted to be an artist, but didn't know how to go about it. I hadn't gone to art school. So in a state of confusion about my purpose, all I could think to do was to find a way to return to America, trusting that somehow, there, I could more easily work these things out. That's an oversimplification of something that was more complicated and anguished, but it is not inaccurate.

And your feeling turned out to be right?

After I had been in New York for a while, I discovered or perhaps re-discovered the sense of freedom that exists there. The society I grew up in in England was so homogenous. After you spoke a few sentences, people thought they knew all about you. The worst of it was that 95% of what they thought they knew was probably true. At the time, I was quite shy, and didn't know how to find a path to art or to some sense of a greater inner freedom in that atmosphere. Now, that feels like a long time ago and a different person speaking, but that was my state of mind at the time. So it was a revelation to find myself in New York with the possibility of re-casting myself. I found that in New York if someone said they were a poet, others were only concerned with whether the poems were good. I remember realizing this starkly when I was reading a novel by Dashiell Hammett. I had not heard of him before, though in England, I had been in the habit of reading detective stories. I was astonished both by the quality of the writing and his evident firsthand familiarity with police work and sleuthing. In England, then, if a local policeman with years of experience of police work had confided to his peers that he was writing a novel, he probably would have been chided for giving himself airs and pretensions.

So there was a real palpable sense of freedom in New York by contrast.

Right. But a big part of that was also money. In New York, I saw that someone with ambition in the arts could begin the process of trying to realize that ambition while simultaneously supporting themselves in ways that were not all-consuming. I had friends who drove taxis or did drywall construction on the side. The rent for my first loft in the Lower East Side was $106 a month. You could make $50 a day driving a taxi, so by working just a few days a month you could pay for a studio, which was probably also a place to live. That just wasn't possible in London. An artist in London who was just out of art school

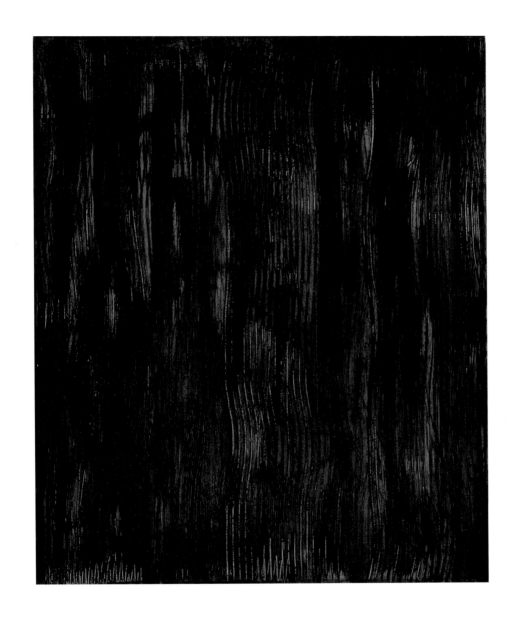

Untitled 2001

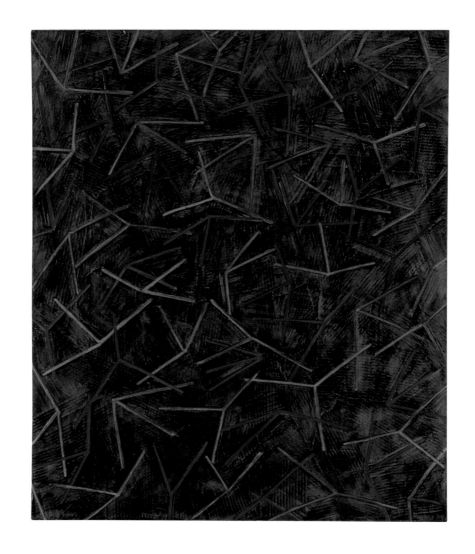

Untitled 2003

could teach or work as an assistant to an older artist, but that was about it. Driving a taxi in London, for instance, required a full year of study and an exam. So part of what was so novel about the freedom of New York was just the way you could go about living. That and the fact that New York seemed to allow the possibility to invent yourself more easily than elsewhere. I had grown up in an environment where people were defined so rigidly, so when I first arrived, New York was a revelation.

So was it in New York that you really began to consider yourself an artist?

It was definitely the first time I could see a real path to working to become one. I was always interested in art. I went to museums with my parents, but I wasn't so alert when I was younger. I didn't know how to pay attention to the way things were painted, even though I painted myself. When I was in my late teens, I began to realize that paintings could contain much more than I had previously understood. I saw that a painting was an object, before it was an image. That it could contain abstract ideas as well as narrative. I started looking at art differently and imagining what it would be like to make art. At Cambridge, I knew I wanted to be an artist, but I did not know how to go about it. I hadn't really been exposed to anyone who was an artist. It was then that I met Mark Lancaster.[8] He was the artist in residence at Kings College. He was there for two years, essentially to live his life and serve as an example to students in the community.

How did you first meet Mark Lancaster?

I vividly remember an exhibition of his at a little museum in Cambridge. I liked his work and I knew his role was not to teach (one could not, and still cannot, study painting at Cambridge or Oxford), but essentially just to be there, so I impulsively decided to visit him on my way back from the exhibition. When I went up to his room, his door was wide open and there was music playing. As I looked through the door into the studio, I could see all sorts of framed work hung along the walls into the main room. I was torn because I wanted to see the work, but it felt rude to go in if he wasn't there. Even to visit someone whom I did not know was an unusual thing for me to do. But I entered the room, thinking I could get a quick look and then leave before being "caught," as it were. Then, just as I was on my way out, Mark returned. He did not seem troubled by my intrusion, but was very friendly and forthcoming and made some tea. He and I were friends for the rest of my time at Cambridge. I met a number of practicing artists through him. He was the first person I knew who constructed his life around making art. That had been a theoretical thing for me in the past, but I had never observed it firsthand. As I got to know him better, it became more and more significant for me to see that there really was a straightforward way to organize one's life around making art.

I can imagine that there was a tight knit community of artists and a range of ways that people organized their lives around making art in New York when you arrived there in the 70s.

8 Mark Lancaster, b.1938, England, abstract artist and set designer.

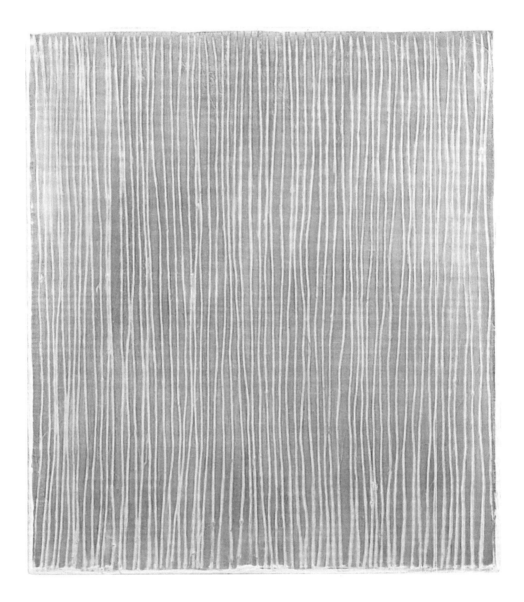

Untitled 2003

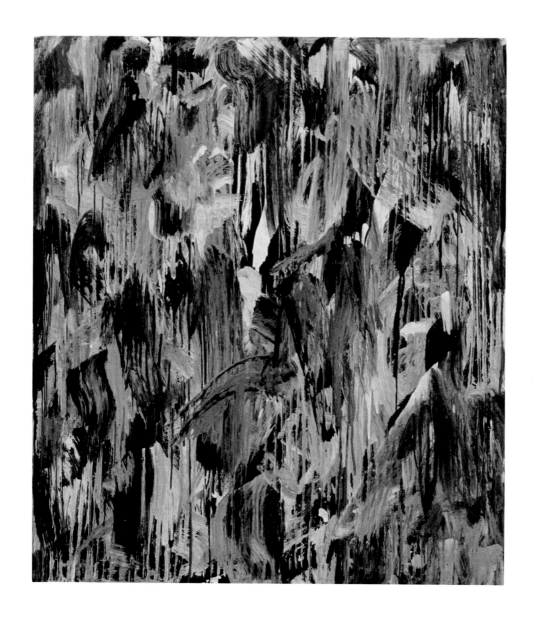

Untitled 2003

Yes, it was a small world then. There were only two galleries in SoHo. Living in lofts in SoHo was illegal, so pretty much only artists and their families lived in that downtown area. There were only two bars: Fanellis, a spot that had survived from the time that the area was full of light industry, and the Spring Street Bar, which was newer and catered to the local artists. You would always run into someone you knew at Spring Street. Later, other places, like Max's Kansas City, popped up. That was another place where you would always find familiar faces.

After a little while in New York, I met a number of people through Mark Lancaster, including Jennifer Bartlett,[9] with whom I became close. And one way or another, through Jennifer and evenings at Spring Street and really just by being there, I became friends with a number of artists. We spent a lot of time in people's studios. Most people lived in their studios and we would have dinners there. People would bring their kids, we drank two sorts of cheap wine that came in big gallon containers. We would discuss work and exhibitions we'd seen recently, but also rent and real estate and other such things. I didn't go to art school—it was less anomalous back then than it might be today—so visiting friends' studios was really how I was exposed to a lot.

How did this community influence your work?

Well, I found the work all my friends were doing interesting. Even work that was really different from what I could imagine creating would expand the way I thought about art. Jonathan Borofsky's[10] work counting and writing numbers toward infinity, for instance. I remember a dinner at Elizabeth Murray's[11] studio in the West Village—it was a big old building that had been converted to subsidized housing—where Borofsky was describing his recent project. It was a kind of "zen thing," I suppose, where he wanted to see what would happen if he just sat and did nothing, trying to quell any need to make art. I couldn't quite imagine what he meant, or how he would sustain the practice (he did not for very long), but he was so determined and so obviously bright that it was impossible not to take him seriously. When you're young like I was and come to a situation like New York at that time, everything is fascinating. I learned a sense of persistence and determination from my friends. And an acceptance of the fact that it is okay to do something without knowing what it is exactly you are doing.

What about the impact of an older New York generation and Abstract Expressionism?

I find abstract art to be a bottomless well of rewards, largely because it leaves so much room for the imagination, for different ways of thinking and seeing. It was the Abstract Expressionists who led me to understand that. I'm not sure I could have understood abstraction in that way, from Mondrian or Malevich, for instance. There were a few galleries downtown and a few clustered near each other uptown, so it was not too difficult to see pretty much all the exhibitions at any given time. I was friendly with Jack Tworkov,[12] and I remember seeing a couple of shows uptown of new work of de Kooning's. He was

9 Jennifer Bartlett, b. 1941, Long Beach, conceptual painter and printmaker.
10 Jonathan Borofksy, b. 1942, Boston, sculptor and printmaker.
11 Elizabeth Murray, b. 1940, Chicago, d. 2007, New York, painter, printmaker and draughtsman.
12 Jack Tworkov, b. 1900, Poland, d. 1982, Provincetown, abstract expressionist painter.

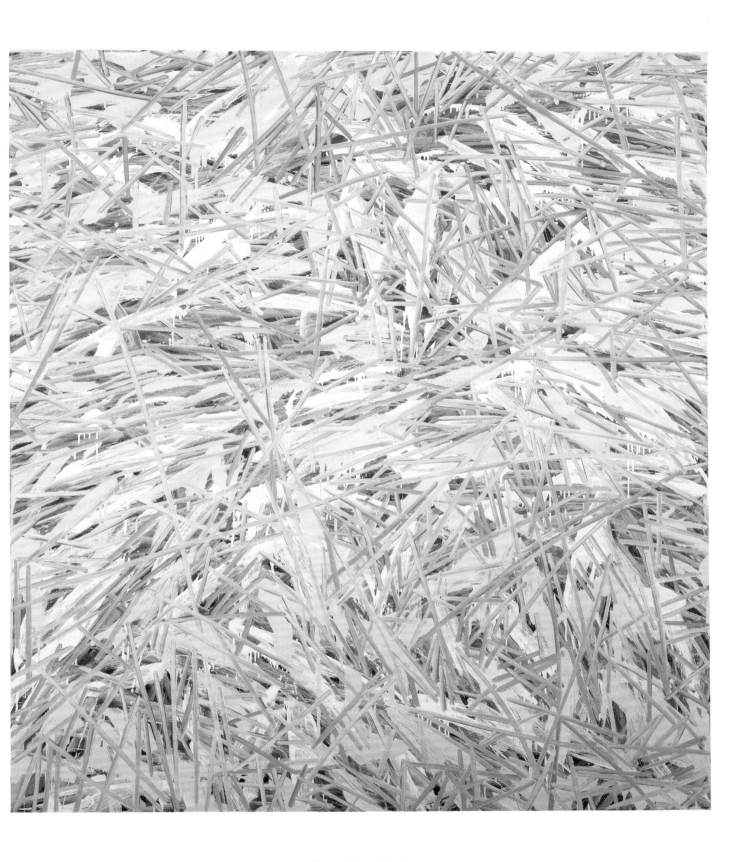

Untitled 2003/2004 The Metropolitan Museum of Art, New York

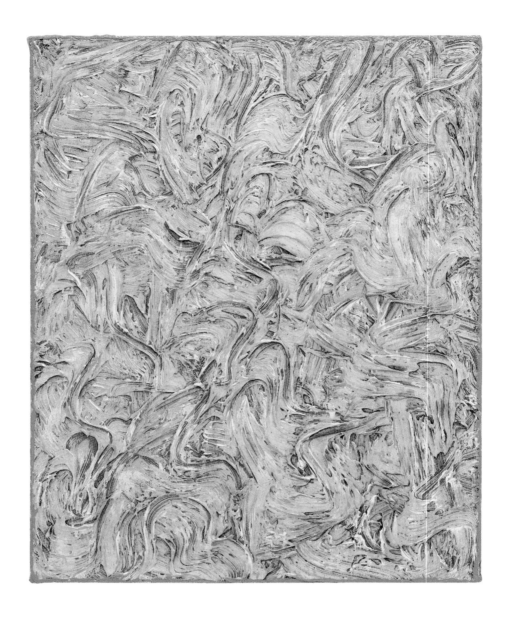

Untitled 2007

[13] *Picasso: The Last Years, 1963–1973*, Guggenheim Museum, New York, March 2 – May 6, 1984.
[14] *Jasper Johns*, The Whitney Museum, New York, October 18 – January 22, 1977.
[15] *I like America and America Likes Me*, Rene Block Gallery, New York, May 1974.
[16] *Joseph Beuys Retrospective*, Guggenheim Museum, New York, November 2, 1979 – January 2, 1980.
[17] Gilbert Proesch, b.1942, San Martin de Tor and George Passmore, b.1942, Plymouth are a collaborative art duo known for their bright, photo-based graphic works and highly formal performance art.
[18] Robert Rauschenberg, b.1925, Texas, d.2008, Florida, painter and graphic artist known for his enthusiasm for popular culture and innovation of technique and medium.
[19] Barry le Va, b.1941, Long Beach, sculptor and installation artist who was a leading figure of post-studio and process art.
[20] Robert Ryman, b.1930, Nashville, painter best known for abstract white-on-white paintings.
[21] Elsworth Kelly, b.1923, New York, d.2015, New York, American painter, sculptor and printmaking associated with hard-edge painting.
[22] Vito Acconci, b.1940, New York City, d.2017, New York City, performance and installation artist, designer and landscape architect.
[23] Bridget Riley, b.1931, West Norwood, painter associated with Op Art.
[24] Barry Flanagan, b.1941, Scotland, d.2009, Spain, sculptor known for bronze animal sculptures.
[25] Ray Johnson, b.1927, Detroit, d.1995, New York City, collagist and correspondence artist, seminal figure in Neo-Dada and early pop art.
[26] Carl Andre, b.1935, Massachusetts, minimalist sculptor and installation artist known for linear and grid format sculptures.
[27] Frank Stella, b.1936, Massachusetts, painter, sculptor and printmaker associated with minimalism and post-painterly abstraction.
[28] Neil Jenney, b.1945, Connecticut, realist painter in a style termed "Bad Painting".
[29] Joe Zucker, b.1941, Chicago, artist known for idiosyncratic use of materials.

the most prominent first generation Abstract Expressionist still making work then.

How do you gauge the impact those exhibitions or your peers had on your work?

Were there any exhibitions that stood out in particular in those days?

There are many, but I am not sure I can keep them all in sequence. I was impressionable and affected by many exhibitions for different reasons. There was a big exhibition of late Picasso paintings at the Guggenheim.[13] People had consistently been so dismissive of his paintings in London and I found myself thinking about Picasso a lot for a time after that. There was also an important show of Jasper Johns at The Whitney.[14] It felt like any younger artist working then had to find a way to negotiate through Johns' work. Joseph Beuys had his first show in America, *I like America and America Likes Me*.[15] It was the inaugural show at the new René Block gallery. He already had a bit of a following amongst the people that I was hanging out with. He was in the gallery with a wild coyote for 10 days, crawling around with his coat, hat and crook. I didn't really understand the show, but I went several times, and it made a strong impression. It was preparation, in any event, for the big Beuys retrospective at the Guggenheim a few years later.[16] The exhibition certainly created a lot of excitement, interest, and controversy among the local art scene.

How do you gauge the impact those exhibitions or your peers had on your work?

Assessing impact is, in itself, a difficult task. Sometimes, an exhibition, even one that one might admire a lot, can be helpful in clarifying what not to do. It can elucidate an impulse to let go of and leave for others to investigate, rather than a way ahead or something to try in one's own work. In any event, there were numerous shows that had a significant impact on me. Gilbert and George,[17] Robert Rauschenberg,[18] Barry Le Va,[19] Robert Ryman,[20] Ellsworth Kelly,[21] Vito Acconci,[22] Bridget Riley,[23] early Barry Flanagan,[24] Brice Marden, Ray Johnson,[25] Carl Andre,[26] Frank Stella[27] and Neil Jenney.[28] The list goes on. These were all people who expanded my way of thinking.

What was it like to negotiate your own form of abstraction in the wake of AbEx and shows like those?

The weight of what others have done with painting is something one has to attempt to escape from. I am drawn to the activity of painting. The material, the weight, the limitations, the expansiveness. In retrospect, what you realize is that if you persist in doing something, it will look like it is yours. While I was teaching, I tried to encourage younger students to let go of "the anxiety of influence." Even if one makes a deliberate attempt to mimic something, it will most likely emerge as something that is, for better or worse, self-evidently yours. I do remember that when I was first in New York, a few artists I was close to, like Jennifer Bartlett and Joe Zucker,[29] made paintings using eccentric materials. Joe Zucker used cotton balls dipped in paint to render his images. Jennifer Bartlett constructed her work from a singular, consistently-sized steel plate covered

in white, baked enamel and then screen printed with a grid. Then she arranged plates in a grid and worked on them with enamel paint. I was envious of the fact that working this way, guaranteed at least one form of explicit originality and made the works immediately recognizable. I always knew I didn't want to go that route, though. I preferred to use traditional materials and means. This meant it would take longer to find a voice, but I hoped to eventually reach a place where I would prefer to be.

When did you start sharing your own work with your peers?

I chose to make my own work in some kind of privacy and seclusion for some time. This was partly because I felt that I did not really know what I was doing. When I decided not to go to art school, I had reasoned that I could always find out techniques as I needed to know them. I didn't realize that perhaps the most important aspect of art school is not so much what students are taught, but the time a young artist spends working amongst peers, sharing work and ideas with people whose relationship to their work is similarly evolving. I had this sense that I had not properly "paid my dues." This was also something a few of my friends were not reluctant to point out. So finding myself in New York amongst a group of serious and ambitious artists, I resolved to begin finding a way forward quietly. One simply starts somewhere trying to make work. At the beginning, I really did not want or solicit much attention. With time of course, friends and people came by my studio more often. For a while, Walter de Maria[30] had a studio beneath me and we would drop in on each other to chat or for a coffee from time to time. I think that after some time, my reclusiveness with my work had become a habit that was actually no longer useful for me. If, in fact, it ever had been. At some point Clarissa Dalrymple was convinced I should show the work publicly. Since we were close friends, neither of us thought it appropriate that I show work at the Cable gallery, which she ran with Nicole Klagsbrun.[31] So she encouraged Julian Pretto[32] to see my work, and I showed some paintings at his gallery soon after that.

Do you still feel such a strong connection to New York?

When I came to New York initially, it certainly felt as though there was no other place quite like it. Now, I'm sure there are many places that could offer what I found in New York then. But New York has become my home. I have so many friends here of different ages whom I have known for a long time. I do get out of the city quite regularly. By my second or third year in the city, I rented a small house in the Catskill Mountains with a friend. For several years while Jasper Johns was living a few miles north of the city, I rented a house not far from his. Now, I spend part of my time in Kent, Connecticut, but my main studio is still in the city.

What are you working on at the moment?

I am planning to work on some prints soon. I have also been working on a small project in metal for a friend. Otherwise, I am in the studio beginning a new body of work. I am still exploring what it will be.

30 Walter de Maria, b. 1935, Albany, d. 2013, Los Angeles, artist, sculptor and illustrator associated with Minimal, Conceptual and Land Art.
31 Nicole Klagsburn, opened Cable Gallery in New York in 1984 and Nicole Klagsburn Gallery in 1989.
32 Julian Pretto, b. 1945, Chicago, d. 1995, New York, art dealer known for his devotion to young artists, opened a number of small galleries in SoHo, TriBeCa and the West Village.

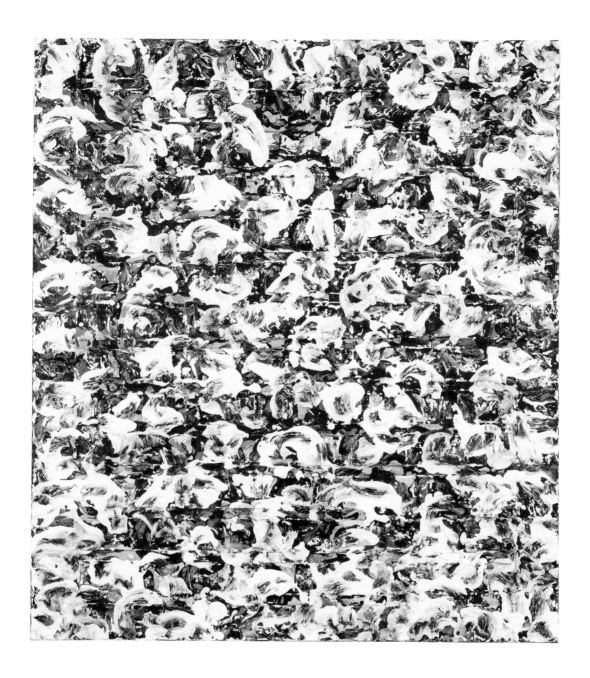

Untitled 2010

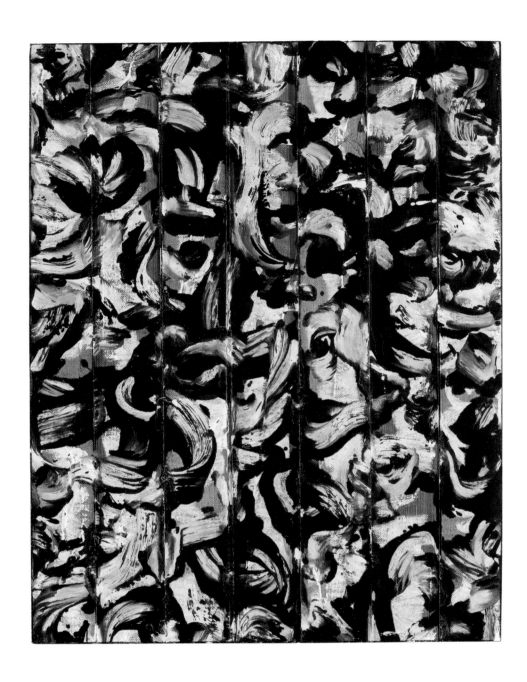

Fragment I 2010/2012

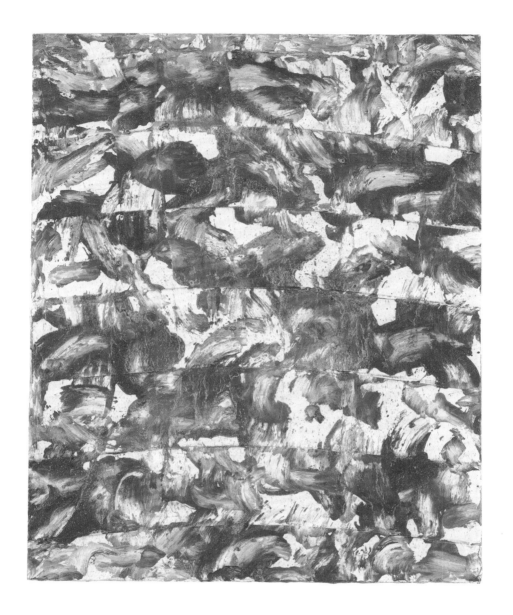

Untitled 2013

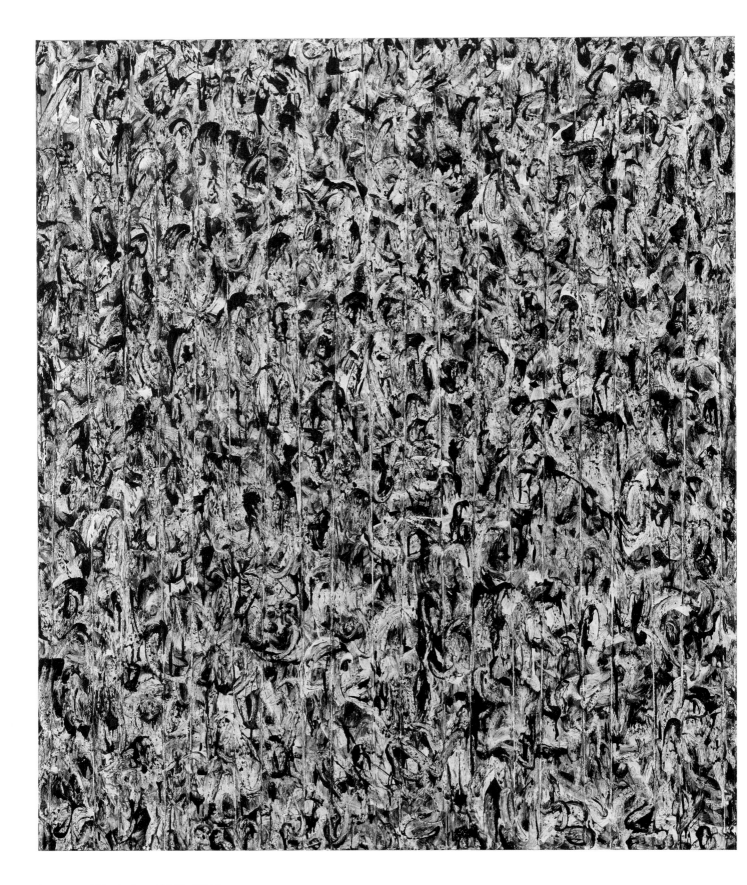

Lacquer Workshop 2012–2015

Julian Lethbridge

Born 1947 in Colombo, SRI LANKA
Brought up primarily in England

Education

1960–1969 Winchester College and Cambridge
University, ENGLAND

1972–present Living and working in New York City

1999–2008 Adjunct Assistant Professor, Department of
Visual Art, Columbia University School of the Arts

1998–2008 Visiting Lecturer, Department of Visual and
Environmental Studies, Harvard University

Solo Exhibitions

2017
Paula Cooper Gallery, New York, NY
Contemporary Fine Arts, Berlin, GERMANY

2013
John Berggruen Gallery, San Francisco, CA
Paula Cooper Gallery, New York, NY

2009
Paula Cooper Gallery, New York, NY

2007
Paula Cooper Gallery, New York, NY

2003
Marcel Sitcoske Gallery, San Francisco, CA
Paula Cooper Gallery, New York, NY

1999
Drawings and Small Paintings, Paula Cooper Gallery,
New York, NY

1997
Adelson Gallery, Aspen Institute, Aspen, CO

1996
Schmidt Contemporary Art, Saint Louis, MI

1995
Recent Paintings, Paula Cooper Gallery, New York, NY

1993
Karsten Schubert LTD., London, ENGLAND

1992
Stuart Regen Gallery, Los Angeles, CA
Recent Paintings, Paula Cooper Gallery, New York, NY

1989
Paula Cooper Gallery, New York, NY
Daniel Weinberg Gallery, Los Angeles, CA

1988
Julian Pretto Gallery, New York, NY (Paintings)
Julian Pretto Gallery, New York, NY (Drawings)

Group Exhibitions

2017
Salon Des Fidèles, Contemporary Fine Arts, Berlin, GERMANY

2016
Material Considerations, John Berggruen Gallery, San
Francisco, CA

2013
Julian Pretto Gallery Show, MINUS SPACE, Brooklyn, NY

2011
*Three Artists: Julie Mehretu, Julian Lethbridge and Wayne
Gonzales*, John Berggruen Gallery, San Francisco, CA

2007
Looking Back: The White Columns Annual, selected by
Clarissa Dalrymple, White Columns, New York, NY
*Contemporary Art at the Colby College Museum of Art:
Gifts From the Alex Katz Foundation*, Colby College
Museum of Art, Waterville, ME

2005
Works on Paper – 2005, Schmidt Contemporary Art,
St. Louis, MO

2004
New Faculty-Spring, Carpenter Center for the Arts,
Harvard University, Cambridge, MA
Devin Borden Hiram Butler Gallery, Houston, TX
Group Exhibition, Paula Cooper Gallery, New York, NY
Prints, Books, and Multiples, Paula Cooper Gallery,
New York, NY

2003
Group Exhibition, Paula Cooper Gallery, New York, NY
Site and Insight: An Assemblage of Artists, curated by
Agnes Gund, P.S.1, New York, NY

2002
*Merce Cunningham Foundation Benefit 50th Anniversary
Art Sale*, Paula Cooper Gallery, New York, NY

2001
Locating Drawing, Doug Lawing Gallery, Houston, TX

2000
Drawings & Photographs, Matthew Marks Gallery,
New York, NY

1999
Four Painters, New Spring Faculty Carpenter Center,
Harvard University, Cambridge, MA
Powder, Aspen Art Museum, Aspen, CO
Drawn from Artists' Collections, The Drawing Center,
New York, NY
Group Exhibition, Paula Cooper Gallery, New York, NY
Prints from the 1990s: Universal Limited Art Editions,
James Kelly Contemporary, Santa Fe, NM
Mixed Bag: Summer Group Show, Schmidt Contemporary Art,
St. Louis, MO

1998
Drawings & Prints from the Paula Cooper Gallery,
Visual Arts Gallery, New York, NY
Travel and Leisure, Paula Cooper Gallery, New York, NY
Artists on Line for ACOR, Gagosian Gallery, New York, NY
University of Alabama at Birmingham, Birmingham, AL
Universal Limited Art Editions, Fay Gold Gallery, Atlanta, GA
Amnesty International Benefit Drawing Show,
Paula Cooper Gallery, New York, NY

1997
Masterworks: New York on Paper, Baumgartner Galleries,
Washington, DC
Independent Curators Incorporated, 1997, Leo Awards Benefit
exhibition and silent auction, 1950 Gallery, New York, NY

1996
On Paper II, Schmidt Contemporary Art, St. Louis, MO
Carroll Dunham, Julian Lethbridge, Terry Winters, Susan
Sheehan Gallery, New York, NY
Changing Group Exhibition Turner Runyon Gallery, Dallas, TX
*ULAE Publications Preview: Rauschenberg, Johns, Winters,
McClelland, Hammond, Lethbridge, Murray, Smith, Dunham
and Jensen*, Thomas Segal Gallery, Baltimore, MD
unconditionally ABSTRACTION, Schmidt Contemporary Art,
St. Louis, MO

1995
From Here, Karsten Schubert LTD, London, ENGLAND
Contemporary Art Society at Butler Gallery, Kilkenny Castle,
Kilkenny, IRELAND

Contemporary Drawing: Exploring the Territory, curated by
Mark Rosenthal, Aspen Art Museum, Aspen, CO
*Prints: To benefit the Foundation for Contemporary
Performance Arts*, Brooke Alexander, New York, NY

1994
*The Inward Eye: Ross Bleckner, Richmond Burton, Julian
Lethbridge*, Laura Carpenter Fine Art, Santa Fe, NM
In the Field, Margo Leavin Gallery, Los Angeles, CA
46th Annual American Academy Purchase Exhibition, The
American Academy of Arts and Letters, New York, NY
Holiday Exhibition, Paula Cooper Gallery, New York, NY

1993
'I Am the Enunciator', Thread Waxing Space, New York, NY
Merce Cunningham Dance Company Benefit Art Sale,
65 Thompson Street, New York, NY
*Exhibition to Benefit The Robert Mapplethorpe Laboratory
for AIDS Research New England Deaconess Hospital*,
Barbara Gladstone Gallery, New York, NY
The Rome Project, David Winton Bell Gallery, List Art Center,
Brown University, Providence, RI
Black and White, Schmidt Contemporary Art, St. Louis, MO
Recent Acqusitions: Sculpture, Painting & Works On Paper,
John Berggruen Gallery, San Francisco, CA
Works On Paper, Jack Hanley Gallery, San Francisco, CA
25 Years (Part II), Paula Cooper Gallery, New York, NY

1992
5th Anniversary Show, Karsten Schubert LTD., London,
ENGLAND
The Vertical Flatbed Picture Plane – En Valise,
Turner and Byrne Gallery, Dallas, TX
Group Exhibition, Mars Gallery, Tokyo, JAPAN
Julian Lethbridge and Sam Reveles Drawings, Paula Cooper
Gallery, 149 Wooster, New York, NY
Drawn in the Nineties (organized by Independent Curators
Inc.), The Katonah Museum of Art, Katonah, New York, NY,
traveled to: Illingworth Kerr Gallery, Calgary, Alberta,
CANADA; Huntsville Museum of Art, Huntsville, AL
Drawings and Works on Paper, Anthony Ralph at
Earl McGrath Gallery, West Hollywood, CA
Small Works Julian Pretto Gallery, New York, NY

1991
Drawings, Karsten Schubert LTD., London, ENGLAND
Object Lessons, Portland Art Museum, Portland, OR
Paintings and Drawings, Daniel Weinberg Gallery, Santa
Monica, CA
Drawings and Watercolors, Paul Kasmin Gallery, New York, NY
Act up Benefit Exhibition, Paula Cooper Gallery, New York, NY

1990
In Memory of James 1984–1988: The Children's Aids Project,
Daniel Weinberg Gallery, Santa Monica, CA
Trisha Brown Dance Company Benefit Art Sale,
Paula Cooper Gallery, New York, NY
Waterworks, ULAE, New York, NY
Group Print Exhibition, Paula Cooper Gallery, New York, NY

1989
Works on Paper, Annina Nosei Gallery, New York, NY
Painting Show, Lorence Monk Gallery, New York, NY
Drawings, Lorence Monk Gallery, New York, NY
Abstract Options, University Art Museum, Santa Barbara, CA

1988
*25th Anniversary Exhibition for the benefit of the foundation for
Contemporary Performance Arts, Inc.*, Leo Castelli Gallery
and Brooke Alexander Gallery, New York, NY
Changing Group Exhibition, Paula Cooper Gallery,
New York, NY
Group Exhibition, Robbin Lockett Gallery, Chicago, IL
Works on Paper, Gabrielle Bryers Gallery, New York, NY
Almost White, Gabrielle Bryers Gallery, New York, NY

1987
Art Against Aids, Cable Gallery, New York, NY

1985
Selections, Artists Space, New York, NY (organized by
Kay Larson)

1984
Sex, Cable Gallery, New York, NY

1982
New Drawing in America, The Drawing Center, New York, NY,
travelled to England and Italy

1980
Foundation for Contemporary Performance Arts Exhibition,
Leo Castelli Gallery, New York, NY
Drawings of a Different Nature, Portland Center for
the Visual Arts, Portland, OR

1979
Choices, The Drawing Center, New York, NY

Other

2004
Visiting Lecturer on Visual and Environmental Studies,
Harvard University, Cambridge, MA

2003
Speaker, New York Studio School Fall Lecture Series,
New York Studio School, New York, NY

2001
Visiting Lecturer on Visual and Environmental Studies,
Harvard University, Cambridge, MA

1999
Contemporary Issues in Abstraction, Carpenter Center
for the Visual Arts, Harvard University, Cambridge, MA
(panel discussion)
Visiting Lecturer on Visual and Environmental Studies,
Harvard University, Cambridge, MA

Awards

1988
Francis J. Greenberger Award

Books & Catalogues

2013
*Artists for Artists: Fifty Years of the Foundation for
Contemporary Arts*, The Foundation for the Arts, 2013.
p.184; illus.

2008
*560 Broadway: A New York Drawing Collection at Work,
1991–2006*, ed. Amy Eshoo. Yale University Press,
New Haven, CT, 2008.

2002
*Department of Visual and Environmental Studies Harvard
University*, VES Faculty 01 02, illus. p.28.

1999
Two by Two for AIDS and Art, benefit auction catalogue,
American Foundation for AIDS Research and The Dallas
Museum of Art, 1999, illus.
Seidner, David. *Artists at Work: Inside the Studios of Today's
Most Celebrated Artists*, Rizzoli, New York, 1999,
pp.178–183, illus.

1997
American Art from the Dicke Collection, exhibition catalogue
from the Dayton Art Institute, 1997. Essays by Todd Smith,
Nancy Green, James Dicke II and Eli Wilner, illus.

Polsy, Richard. *Art Market Guide: Contemporary American Art*, published by the Marlit Press, San Francisco, 1997.

1996
INNOVATION: American Art of Today from the Misumi Art Collection, exhibition catalogue, Kawamura Memorial Museum of Art, edited by Sumi Hayashi, Chiba, Japan, 1996, pp. 66–67; illus.

1995
From Here, catalogue from the exhibition at Karsten Schubert and Waddington Galleries, London, England, 1995.
Rosenthal, Mark. *Contemporary Drawing: Exploring the Territory*, catalogue from the exhibition at the Aspen Art Museum, Aspen, Colorado, summer 1995.

1993
The Rome Studio, catalogue from the exhibition at Bell Gallery, Brown University, Providence, Rhode Island. Preface by Barbara Gladstone and Thea Westreich. Introduction by Diana L. Johnson, 1993.

1992
Götz, Stephan. *American Artists In Their New York Studios: Conversations About the Creation of Contemporary Art*, Harvard University Art Museums, Center for Conservation and Technical Studies, Cambridge, Massachusetts. 1992, Daco-Verlag Gunter Blase, Stuttgart, Germany, pp. 97–101.

1991
Object Lessons, Portland Art Museum, Portland, Oregon, 1991, Essay by John Weber, pp. 16–17.

1989
"The Conditioning of our Time, Abstract Options." January 6–26, 1989. University Art Museum, Santa Barbara, California. Essay by Phyllis Plous, pp. 27–28; illus.

Journals, Magazines and Newspapers

2017
Saltz, Jerry. "To Do-Art: See Julian Lethbridge," *New York Magazine – The Best of New York*, March 6–19, 2017, p. 130

2013
Ebony, David, "Julian Lethbridge at Paula Cooper," *Art in America*, May 2013, p. 166–167; illus.
"The Lookout: A Weekly Guide to Shows You Won't Want to Miss," *Art in America*, February 14, 2013.
Dorfman, John. "Freedom of the Press," *Art & Antiques*, March 2013, p. 70; illus.
"Julian Lethbridge at Paula Cooper Gallery," *Time Out New York*, January 31–February 6, 2013. p. 43.

2009
Kazanjian, Dodie. "Dreaming the Landscape" *Vogue* November, 2009 pp. 216–223; illus.
"Julian Lethbridge" *Time Out New York*, March 12–18, 2009, pp. 48, 50; illus.

2007
"Works on Paper," *Time Out New York*, December 12–26, 2007, p. 118.
Harris, Susan. "Julian Lethbridge at Paula Cooper Gallery," *Art in America*, November 2007, p. 214; illus.
Foshee, Rufus. "Santa Claus in July at Colby," *Knox County Times*, July 28, 2007; illus.
Goodbody, Bridget L. "Julian Lethbridge," *The New York Times*, April 13, 2007, p. E34.

2004
Princenthal, Nancy. "Julian Lethbridge at Paula Cooper," *Art in America*, January 2004, pp. 97–98; illus.

2003
Johnson, Ken. "Gathering a Flock of Quirky Grown-Ups," *The New York Times*, July 18, 2003, p. E32; illus.

Johnson, Ken. "Julian Lethbridge," *The New York Times*, October 3, 2003, p. E37; illus.
"Julian Lethbridge," *The New Yorker*, October 20, 2003, p. 47.

1999
"Julian Lethbridge," *Flatiron*, March/April 1999, p. 57.
"Le body-gemelle e gli anagrammi di Rauschenberg," *Il Giornale Dell'Arte*. No. 176, April 1999, p. 80.

1996
BAMbill, Brooklyn Academy of Music Cover and bio on program cover artist. 1996 Spring Season.
"Julian Lethbridge," *The Print Collector's Newsletter*, Vol. XXVII, No. 2, May/June 1996, p. 64; illus.
Wakefield, Neville. "Julian Lethbridge," *Elle Decor*, Vol. 7, No. 3, June/July 1996.; pp. 52–60; illus.
Wei, Lilly. "Julian Lethbridge at Paula Cooper," *Art in America*, Vol. 84, No. 3, March 1996, pp. 99–100; illus.

1995
Jenkins, Loren. "Drawing: the wellspring of art," *The Aspen Times Gazette*, Summer 1995, pp. 4–5.
Rosenthal, Mark. "Contemporary Drawing: Exploring the Territory," *Aspen Art Museum*, Aspen, Colorado, exhibition hand-out, summer 1995.
Schwartzman, Allan. "Interview with Mark Rosenthal," *Aspen Magazine* on the exhibition "Contemporary Drawing: Exploring the Territory", Midsummer 1995, pp. 59–63.

1994
"Julian Lethbridge, Chapel," *Print Collector's Newsletter*, July/August 1994, p. 107.
Kahn, Eve M. "Talk of the Trade," *Art & Auction*, October 1994, p. 74.
Saltz, Jerry. "A Year in the Life: Tropic of Painting," *Art In America*, October 1994, pp. 90–101.

1993
Bonami, Francesco. "Vitamin P: The Sound of Painting," *Flash Art*, Nov./Dec. 1993, pp. 37–41.
Decker, Andrew. "Collector's Choices," *Artnews*, 10/93, p. 40.
Westfall, Stephen. "Julian Lethbridge at Paula Cooper," *Art in America*, April 1993, p. 133.

1992
"Drawn in the Nineties," Independent Curators Incorporated, Katonah Museum of Art, Katonah, New York.
"Profusion: Julian Lethbridge," *Cover*, Winter 1992/93, p. 9.
Pagel, David. "Art Reviews," *The Los Angeles Times*, July 16, 1992, p. F7.
Wright, Jeffrey. "Galleries," *Art & Antiques*, September 1992, p. 82.

1990
"Julian Lethbridge," *The Print Collector's Newsletter*, November/December 1990, p. 187.
Faust, Gretchen. "New York in Review," *Arts Magazine*, February, 1990, p. 96.
Johnson, Ken. "Julian Lethbridge at Paula Cooper," *Art in America*, March, 1990, p. 205; illus.
Kido, Hitoshi. "Printed Art Today, Part 2. A Printer's Reflexion," *Mizue*, Winter 1990, No. 957, pp. 104–116; illus.
Schwalb, Claudia. "Julian Lethbridge," *Cover*, January, 1990, p. 15; illus.

1989
"Julian Lethbridge," *The New Yorker*, November 20, 1989, p. 18.
Selwyn, Marc. "Three Painters," *Flash Art*, November – December, 1989, pp. 126–127; illus.

1979
Russell, John. "Recent Choices," *The New York Times*, October 5, 1979.

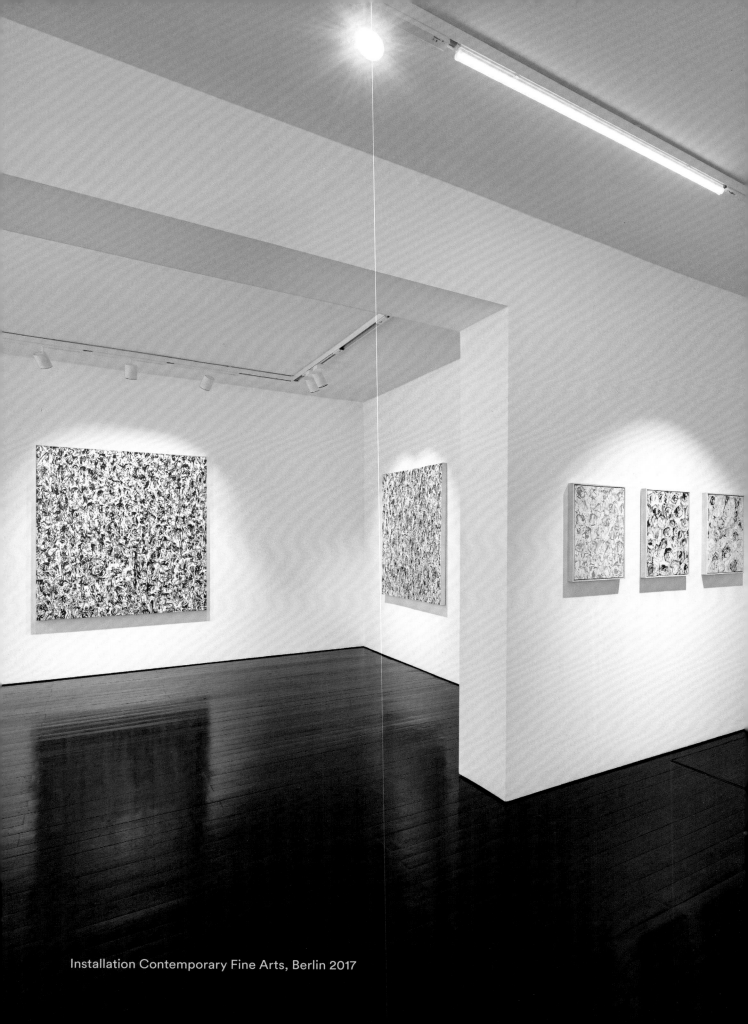

Installation Contemporary Fine Arts, Berlin 2017

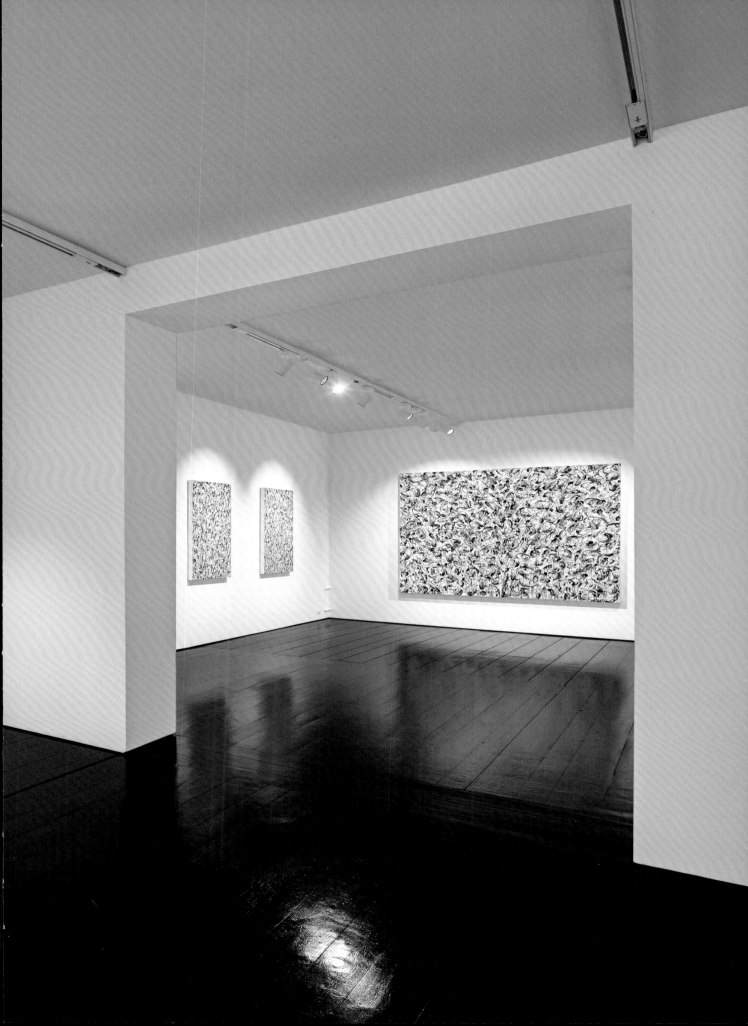

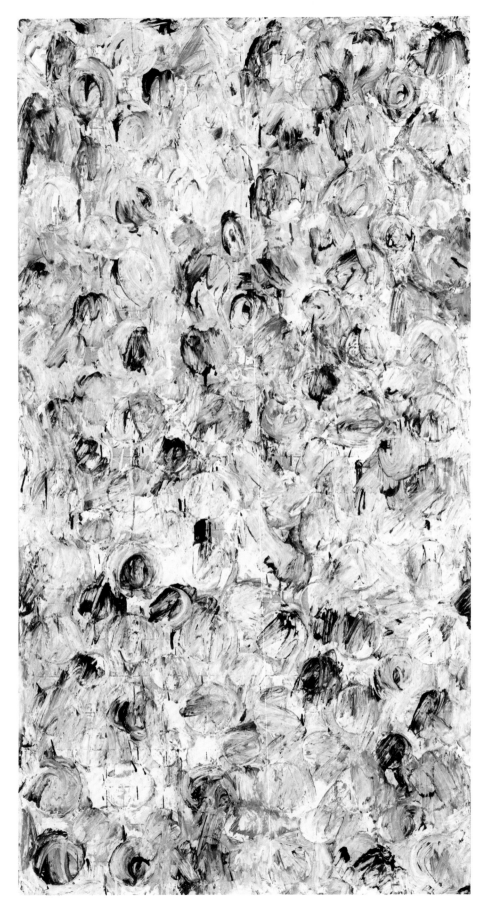

Diode 2015/2016

List of Works

4/5
Installation
Paula Cooper Gallery, New York 2013

6
Core Orbital 2 2015
oil and oil stick on linen
72×36 inches
182.9×91.4 cm

9
Untitled 2015
oil and oil stick on linen
27×21 inches
68.6×53.3 cm

10/11
Lost and Found 2013/2016
oil and pigment stick on linen
60×72 inches
152.4×182.9 cm
Courtesy of Berggruen Gallery

12
Study for Screen Tool 1 2016
oil on canvas
24×20 inches
61×50.8 cm

13
Study for Screen Tool 2 2016
oil on linen
24×20 inches
61×50.8 cm

14/15
Installation
Paula Cooper Gallery, New York 2013

16/17
Untitled 2012
oil and pigment stick on linen
80×96 inches
203.2×243.8 cm

18
Untitled 2013
oil and pigment stick on linen
72×60 inches
182.9×152.4 cm

19
Untitled 2013
oil and pigment stick on linen
60×72 inches
152.4×182.9 cm

20
Suez Passage 2011/2013
oil and pigment stick on linen
42×21 inches
106.7×53.3 cm

21
Water Mead 2013
oil and pigment stick on linen
87×67 inches
221×170.2 cm

22
At Sea 2012/2013
oil and oil stick on linen
96×80 inches
243.8×203.2 cm

23
Untitled 2014
oil on canvas
72×36 inches
182.9×91.4 cm

24+25
Bellows 2015
oil and oil stick on linen
2 canvases, each
45×40 inches
114.3×101.6 cm

26
Argos 2016
oil and pigment stick on linen
80×96 inches
177.8×228.6 cm

27
Stucco 2016
oil and pigment stick on linen
52×42 inches
132.1×106.7 cm

28
Whitehall Dinghy 2016
oil and pigment stick on linen
96×80 inches
243.8×203.2 cm

29
Boreas 2017
oil and pigment stick on linen
52×42 inches
132.1×106.7 cm

30/31
Installation
Contemporary Fine Arts, Berlin 2017

32
First Choice 2016–17
oil and pigment stick on linen
96×80 inches
243.8×203.2 cm

33
Untitled 2016–17
oil and pigment stick on linen
96×80 inches
243.8×203.2 cm

34/35
Good Intentions 2016–17
oil and pigment stick on linen
70×90 inches
177.8×228.6 cm

36
Untitled (Feininger) 1998
oil on linen
18×14 inches
45×35 cm

39
Untitled 1999
oil on linen
25×22½ inches
62.5×56 cm

40
Daufsukie Island 1999
oil on linen
49×39¼ inches
124.5×99.7 cm

43
Untitled 2001
oil on linen
20×16 inches
50.8×40.6 cm

44
Untitled 2003
oil on linen
36×30 inches
91.4×76.2 cm

46
Untitled 2003
oil on linen
24×20 inches
61×50.8 cm

47
Untitled 2003
oil on linen
24×20 inches
61×50.8 cm

49
Untitled 2003/2004
oil on linen
85×76½ inches
215.9×194.3 cm
The Metropolitan Museum of Art,
New York

50
Untitled 2007
oil and oil stick on canvas
10×8 inches
25.4×20.3 cm

53
Untitled 2010
oil and pigment stick on linen
30×25 inches
76.2×63.5 cm

54
Fragment I 2010/2012
oil and pigment stick on linen
18×13½ inches
45.7×34.3 cm

55
Untitled 2013
oil and pigment stick on board
14×11 inches
35.6×27.9 cm

56
Lacquer Workshop 2012–2015
oil and pigment stick on linen
72×60 inches
182.9×152.4 cm

60/61
Installation
Contemporary Fine Arts, Berlin 2017

62
Diode 2015/2016
oil and pigment stick on linen
72×36 inches
182.9×91.4 cm

This catalogue was published
following the exhibitions

Julian Lethbridge
February 16 – March 18, 2017

Paula Cooper Gallery
534 W 21st Street
New York, New York 10011
Tel +1-212-255 1105
Fax +1-212-255 5156
www.paulacoopergallery.com
info@paulacoopergallery.com

Julian Lethbridge
Inside Out
June 10 – September 2, 2017

Contemporary Fine Arts
Bruno Brunnet & Nicole Hackert
Grolmanstraße 32/33
10623 Berlin
Tel +49-30-88777167
www.cfa-berlin.com
gallery@cfa-berlin.de

Text
Robert Storr
Camila McHugh

Photography
(Portrait) Yasuo Minagawa
(Reproductions and installations)
Courtesy Paula Cooper Gallery, New York
Tim Boyce
Mathias Kolb, Berlin

Design
Kühle und Mozer

Production
Snoeck Verlagsgesellschaft mbH
Kasparstraße 9–11
50670 Köln
www.snoeck.de

ISBN 978-3-86442-231-7

Printed in Germany

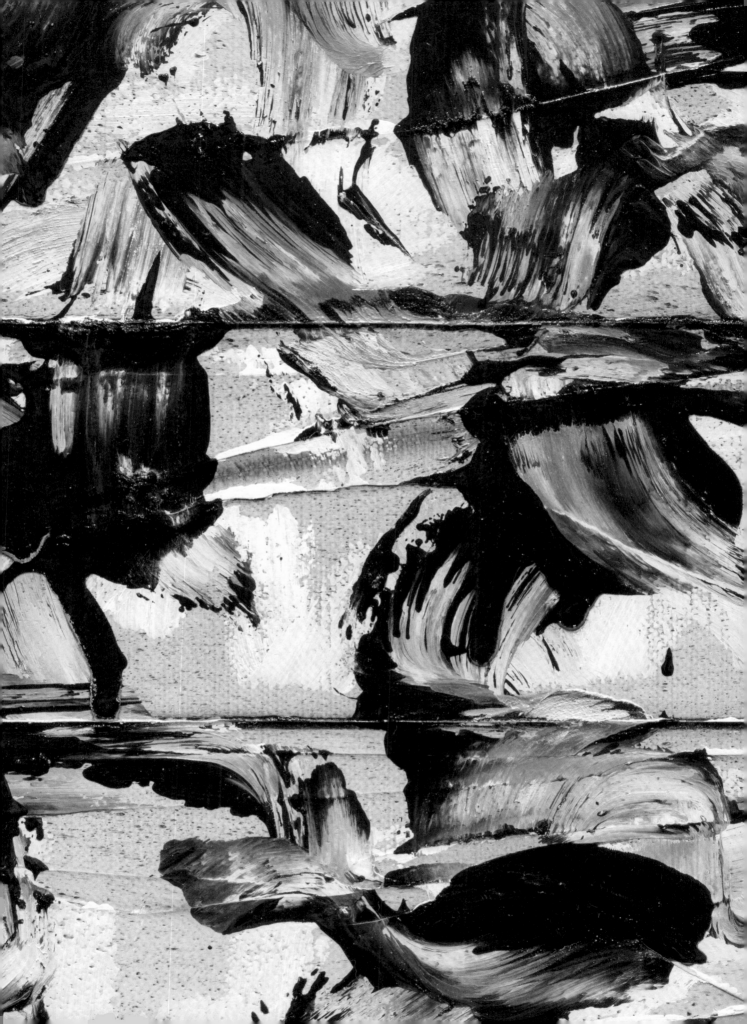

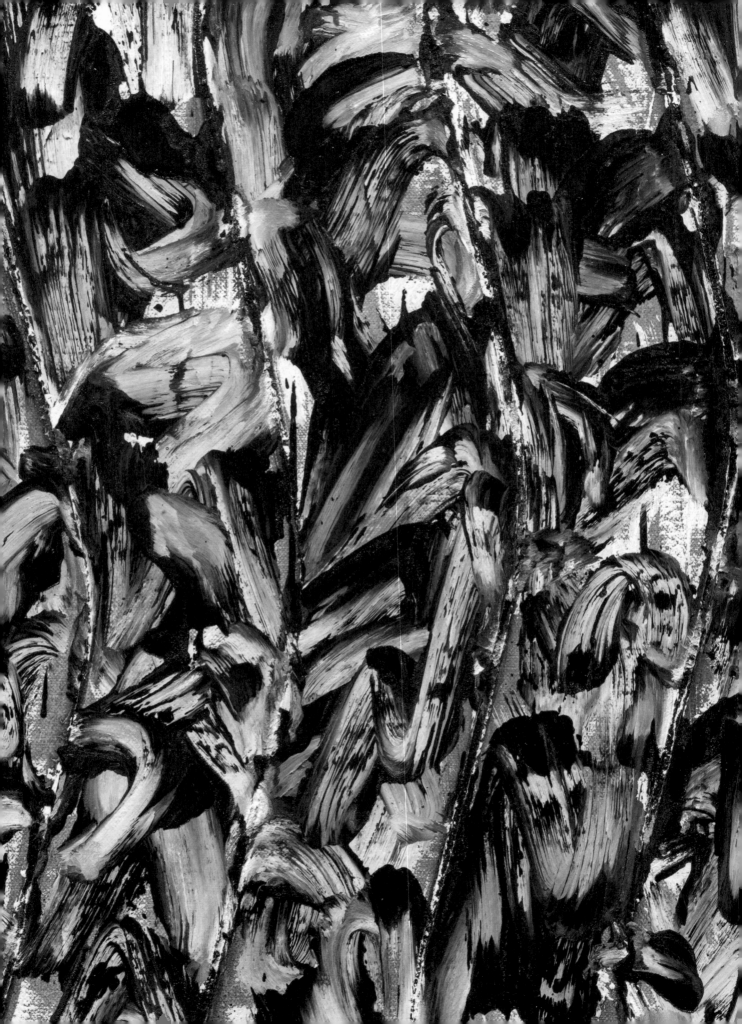